RETRO SCI-FI COLOURING BOOK

Volume 1

Jason Charles

RETRO SCI-FI COLOURING BOOK Copyright © 2019 by Jason Charles. All Rights Reserved.

All rights reserved. No part of this book may be reproduced in any form or by any electronic or mechanical means including information storage and retrieval systems, without permission in writing from the author. The only exception is by a reviewer, who may quote short excerpts in a review.

Cover designed by Jason Charles

This book is a work of fiction. Names, characters, places, and incidents either are products of the author's imagination or are used fictitiously. Any resemblance to actual persons, living or dead, events, or locales is entirely coincidental.

Printed in the United States of America

First Printing: Mar 2019

Retro sci-fi

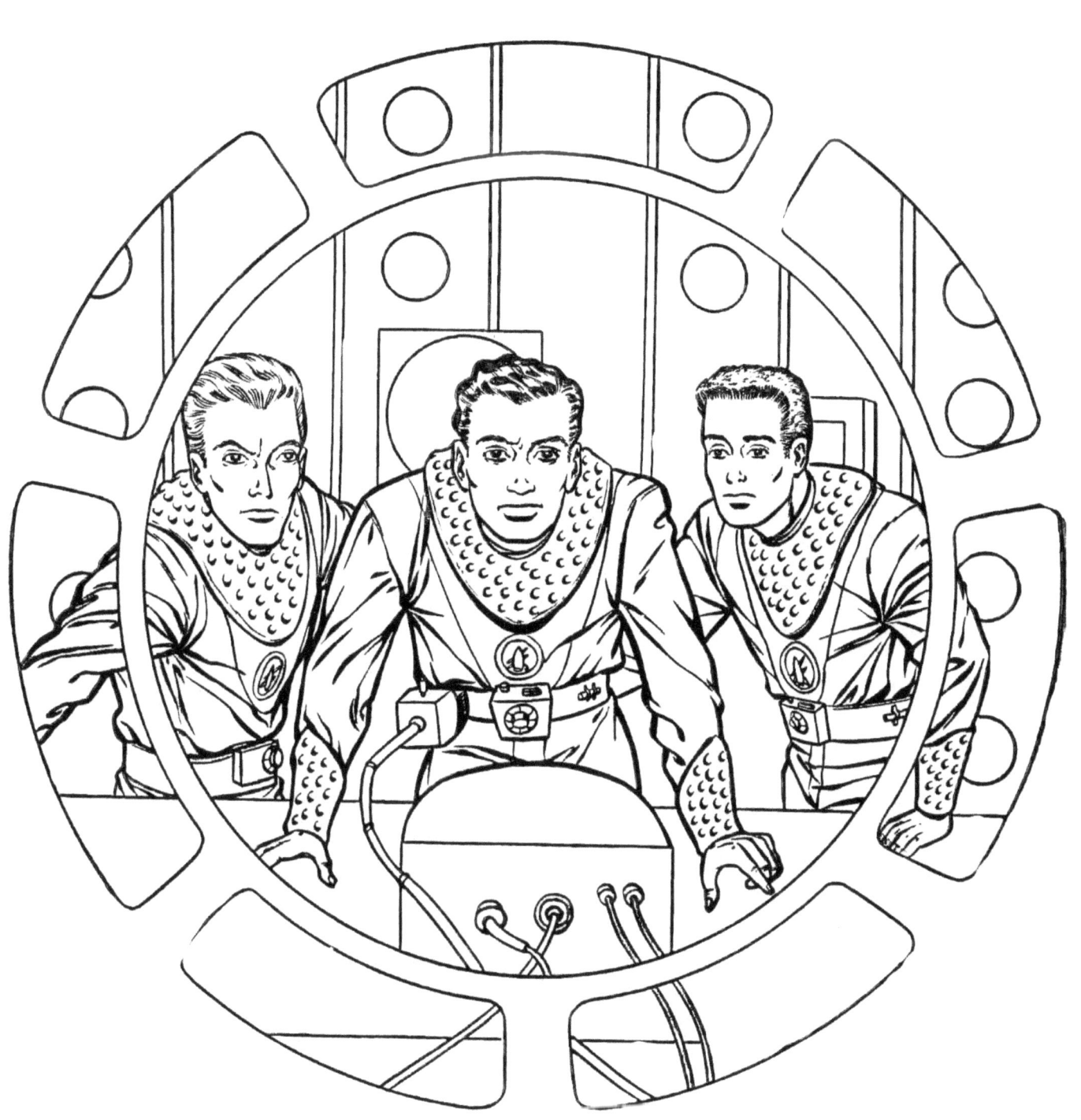

Tom and Commander Arkwright discuss proposed flight

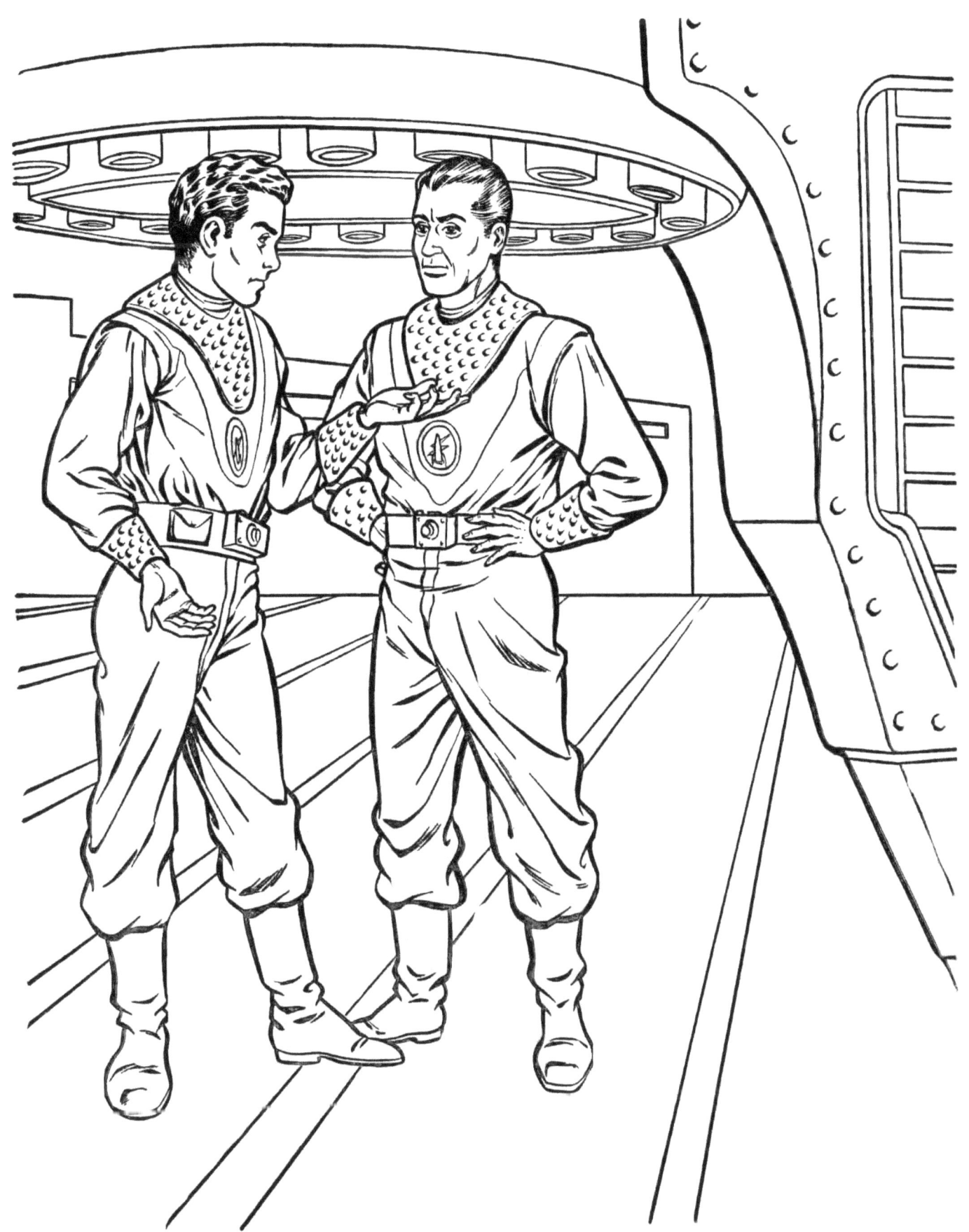

Commander Arkwright and Captain Strong making plans

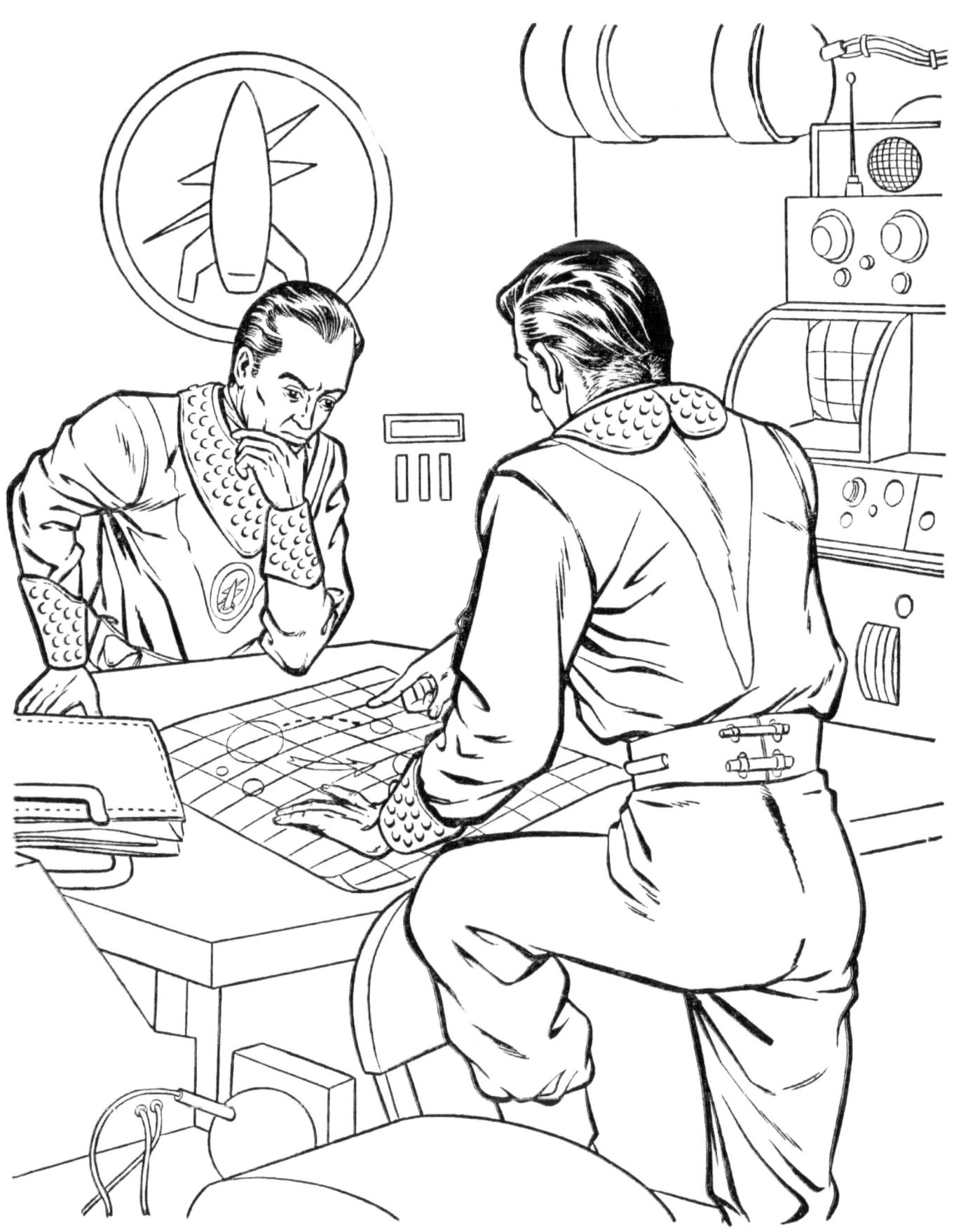

FLIGHT BRIEFING

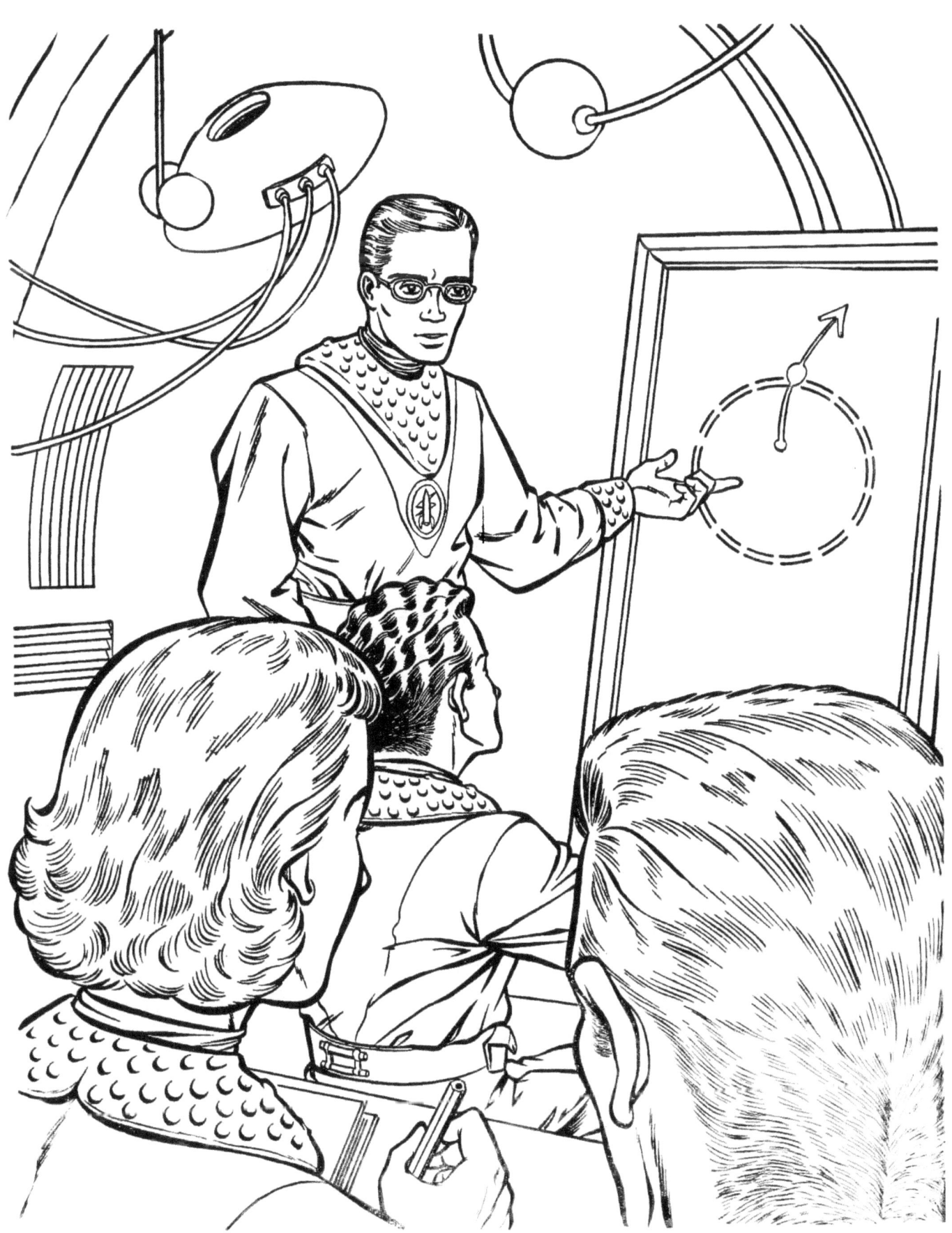

FUELING UP

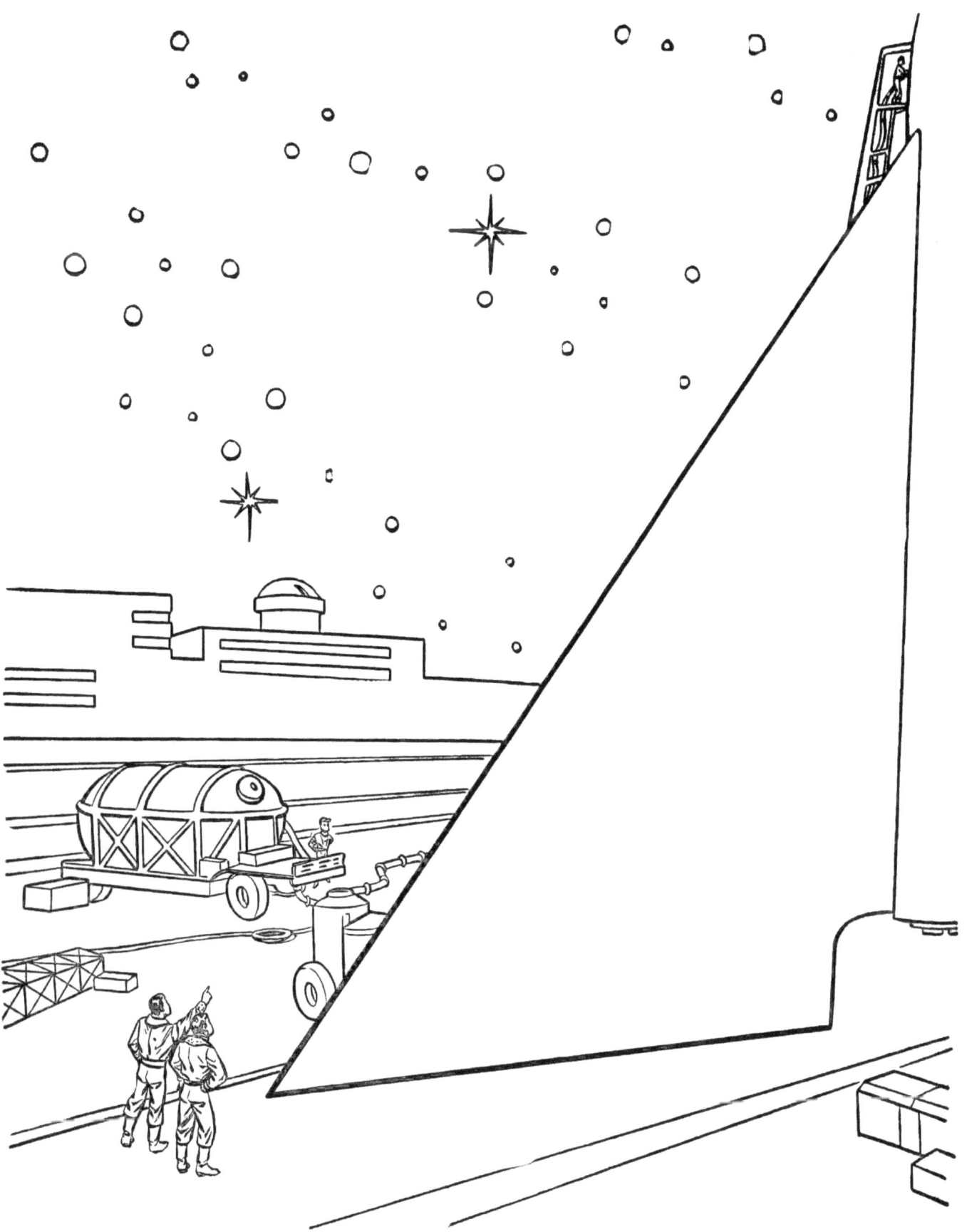

BOARDING TO RAISE SHIP

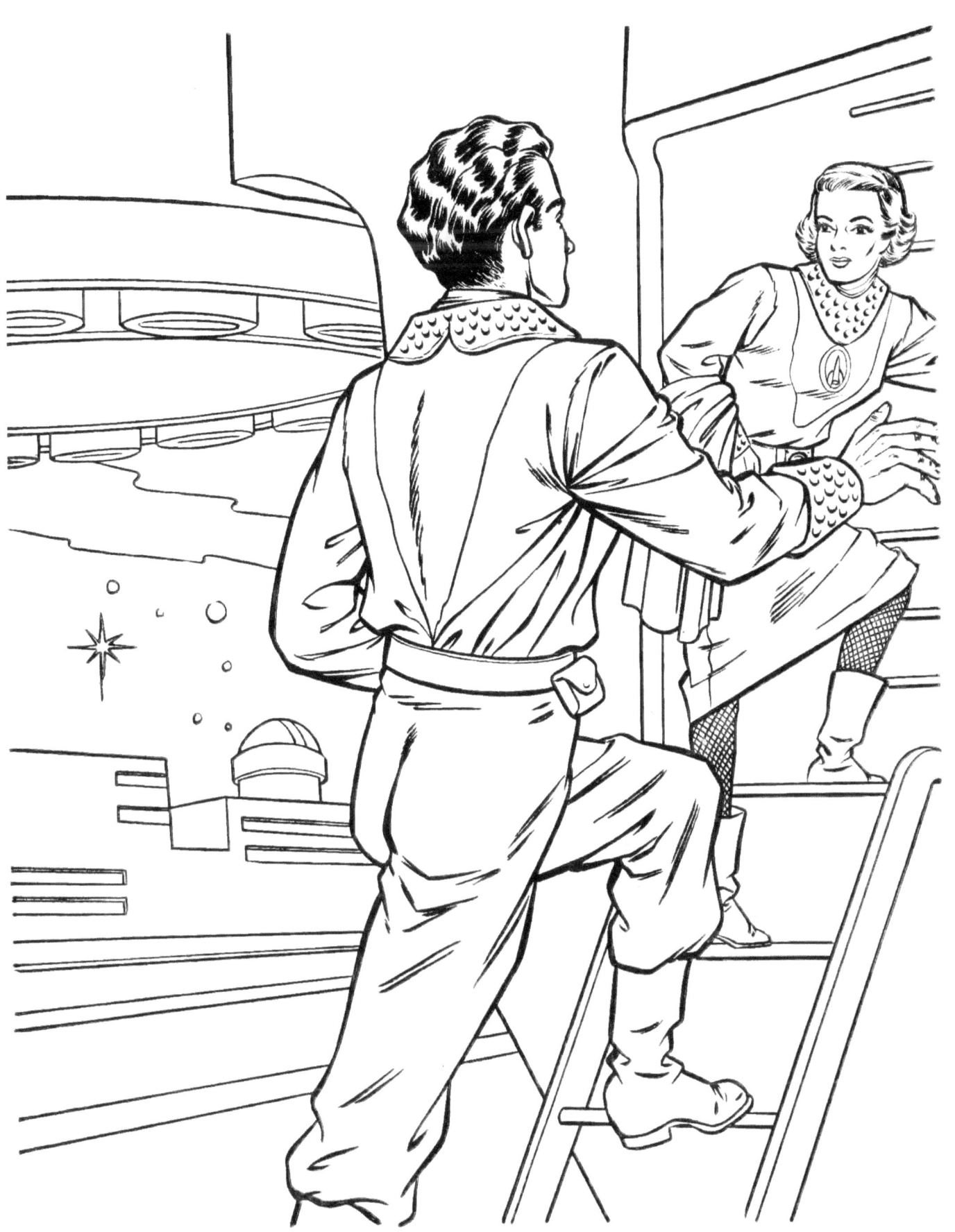

EMERGENCY CHANGE IN COURSE

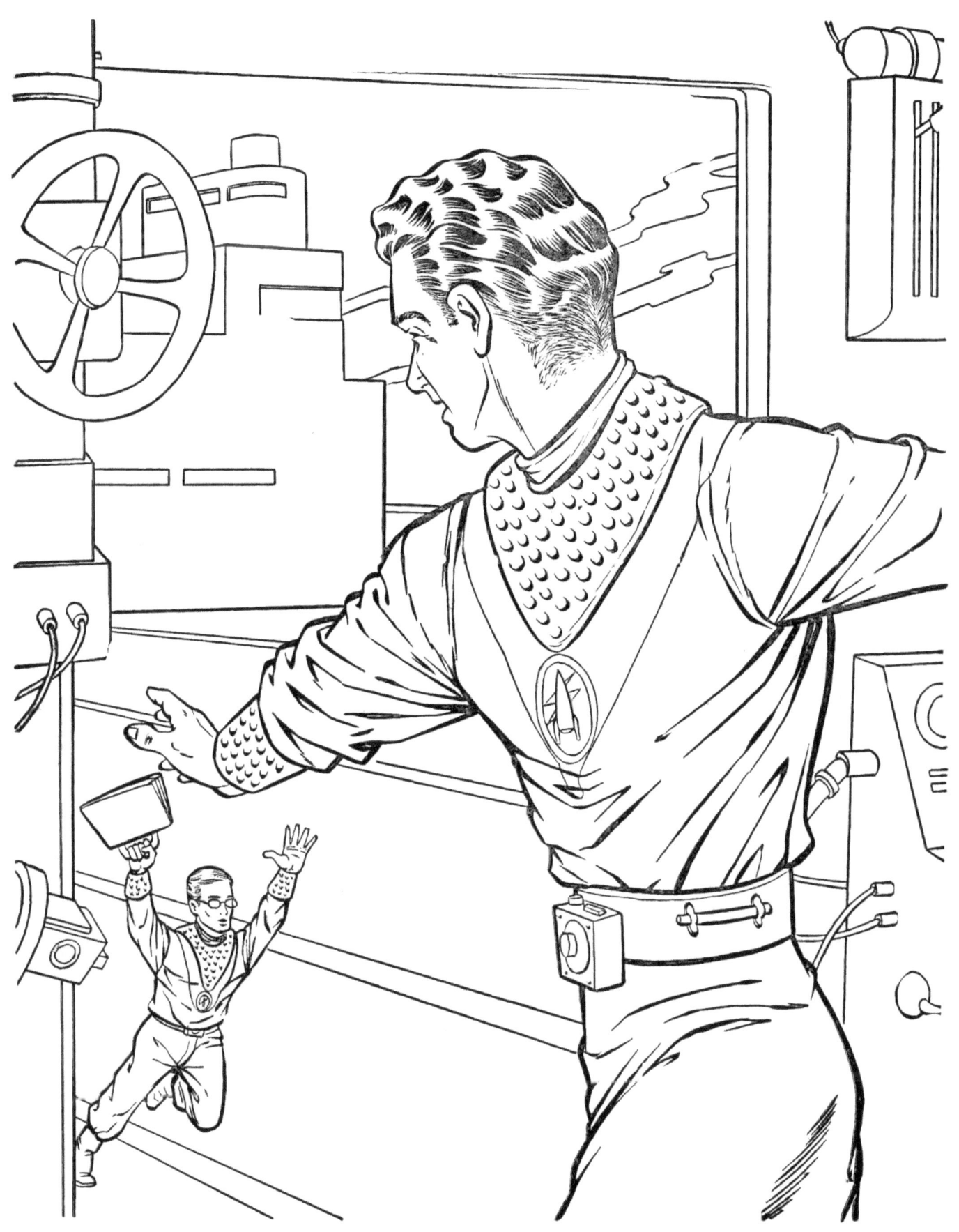

THE BLAST OFF

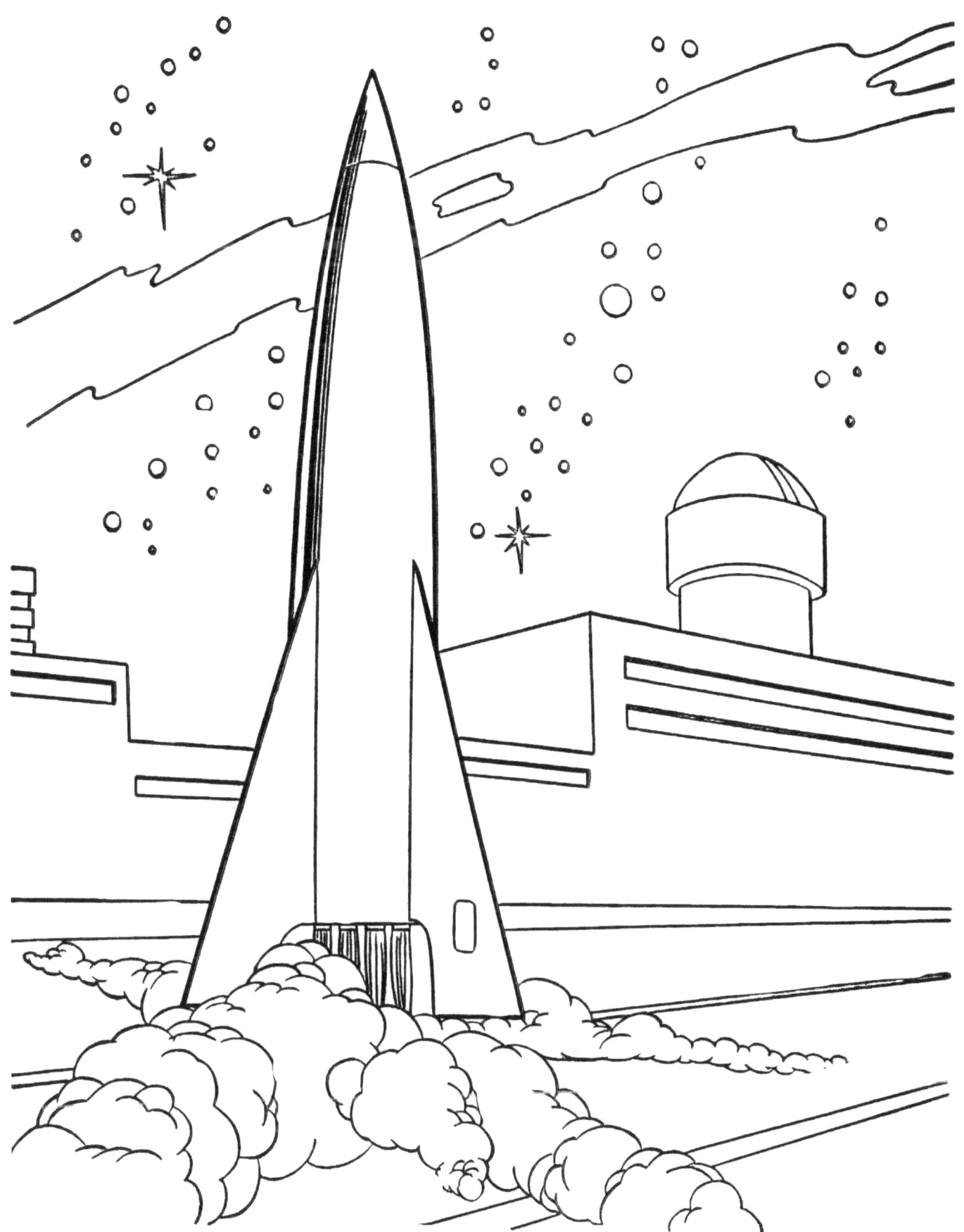

ACCELERATION!

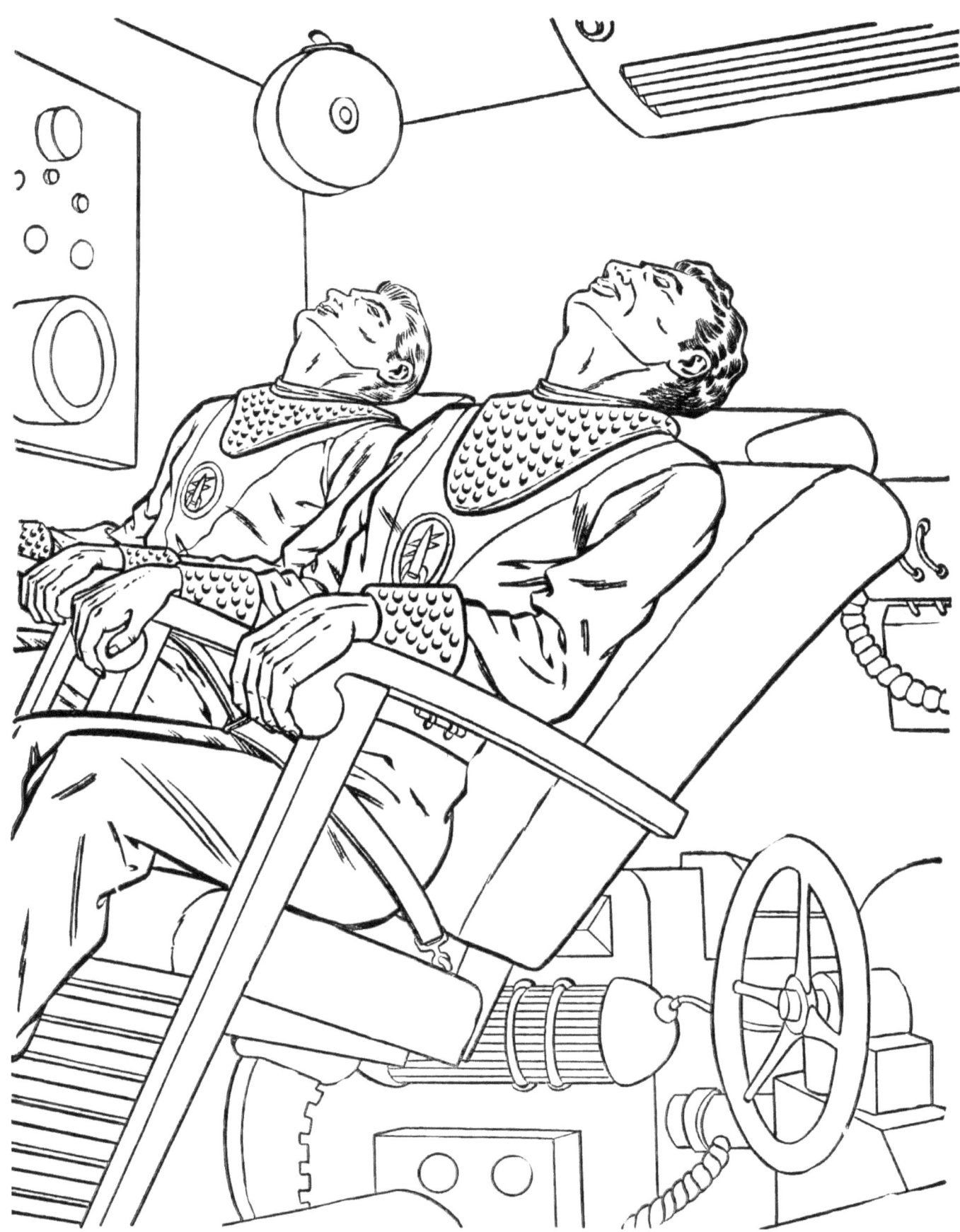

BREAKING THROUGH THE ATMOSPHERE

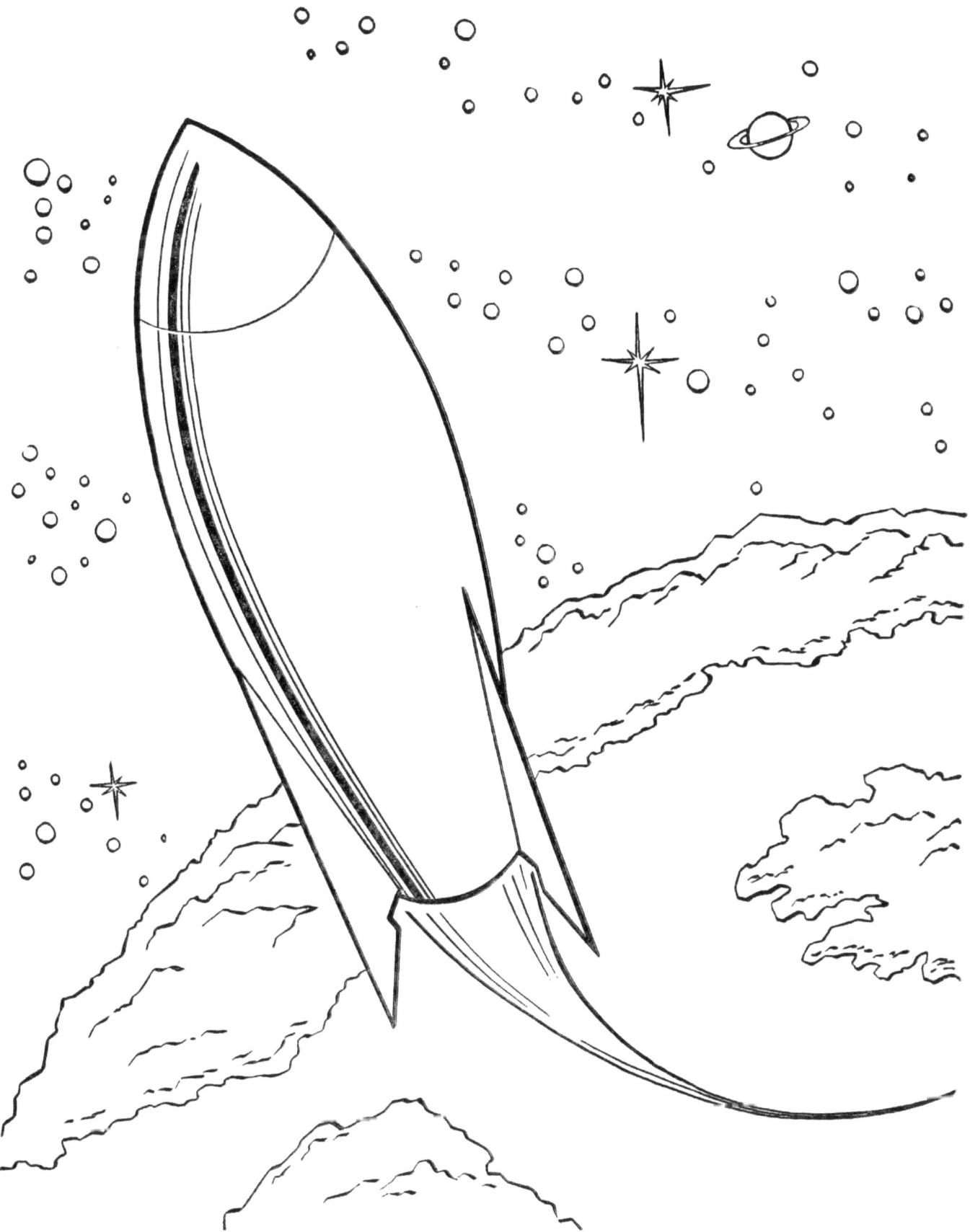

A LITTLE FUN ABOARD SHIP

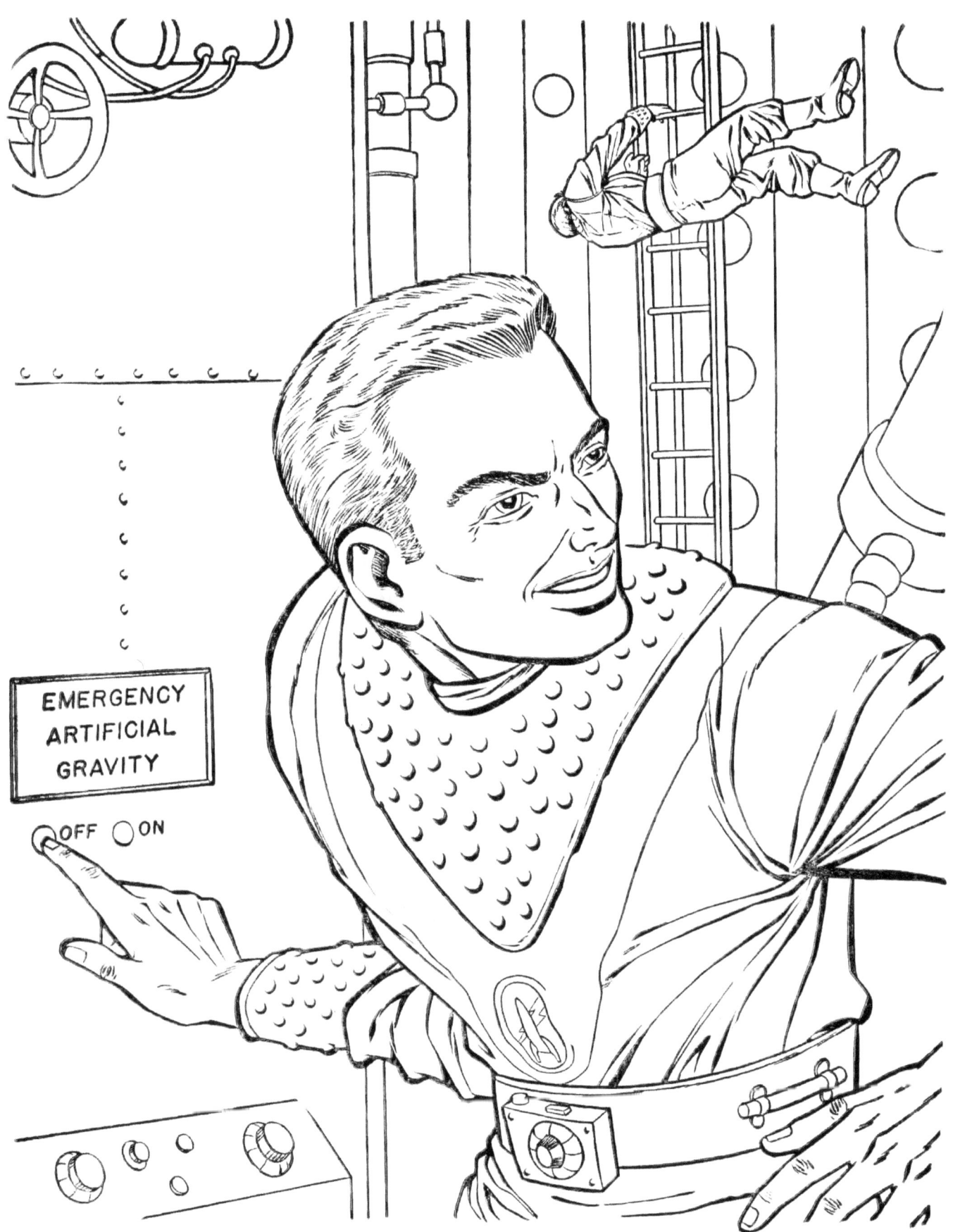

LOSING POWER

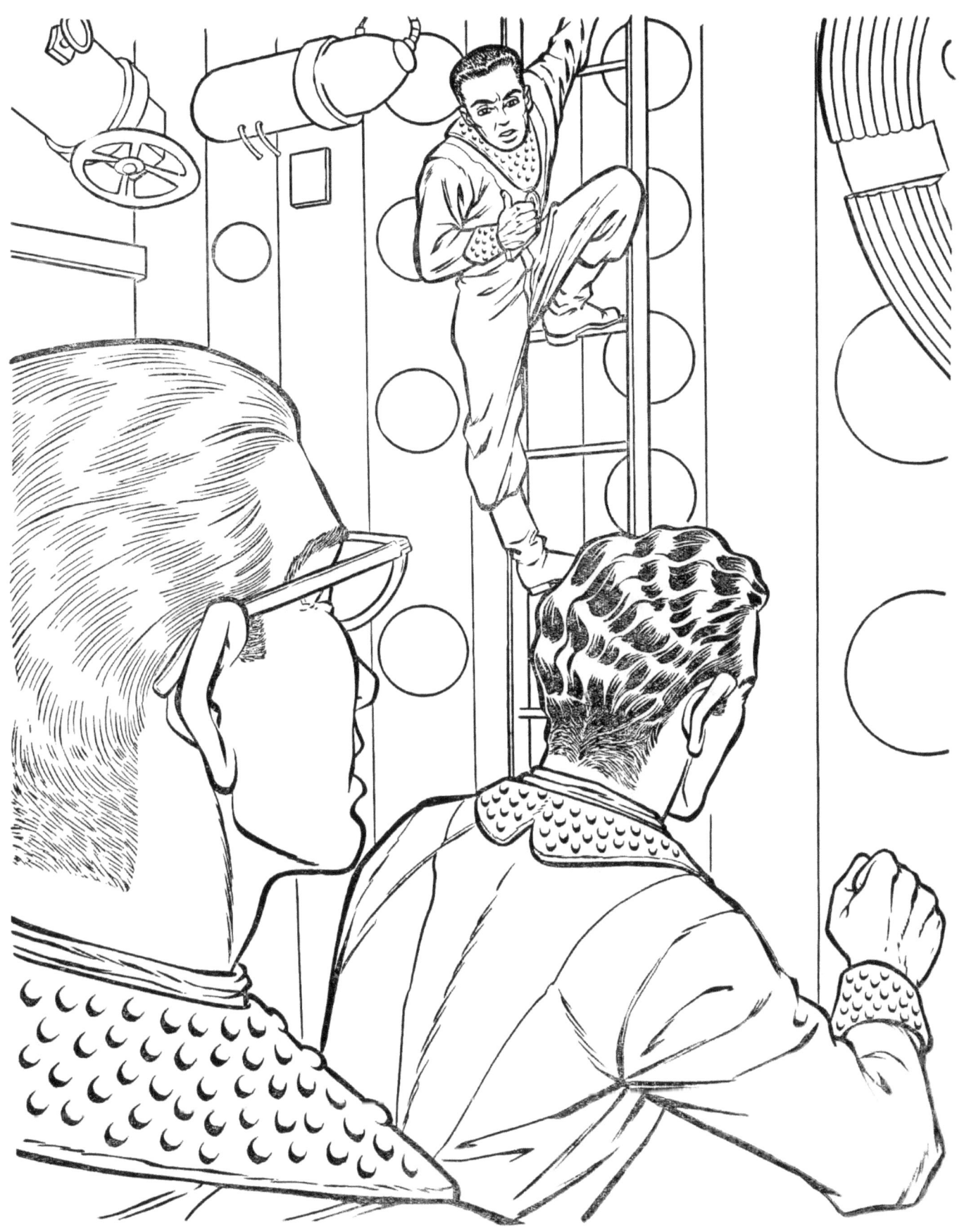

STRO INVESTIGATES

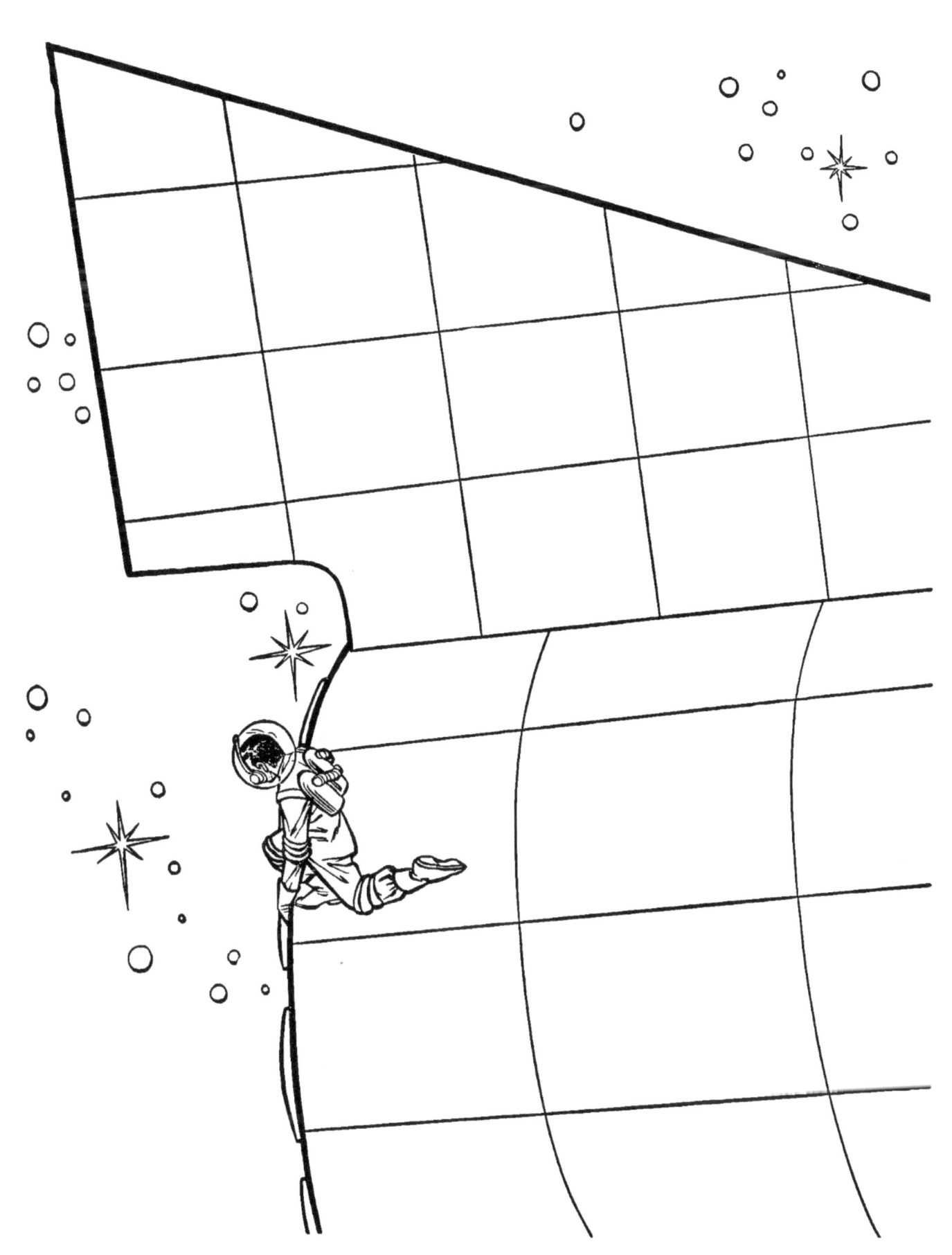

ROGER SUITS UP TO HELP

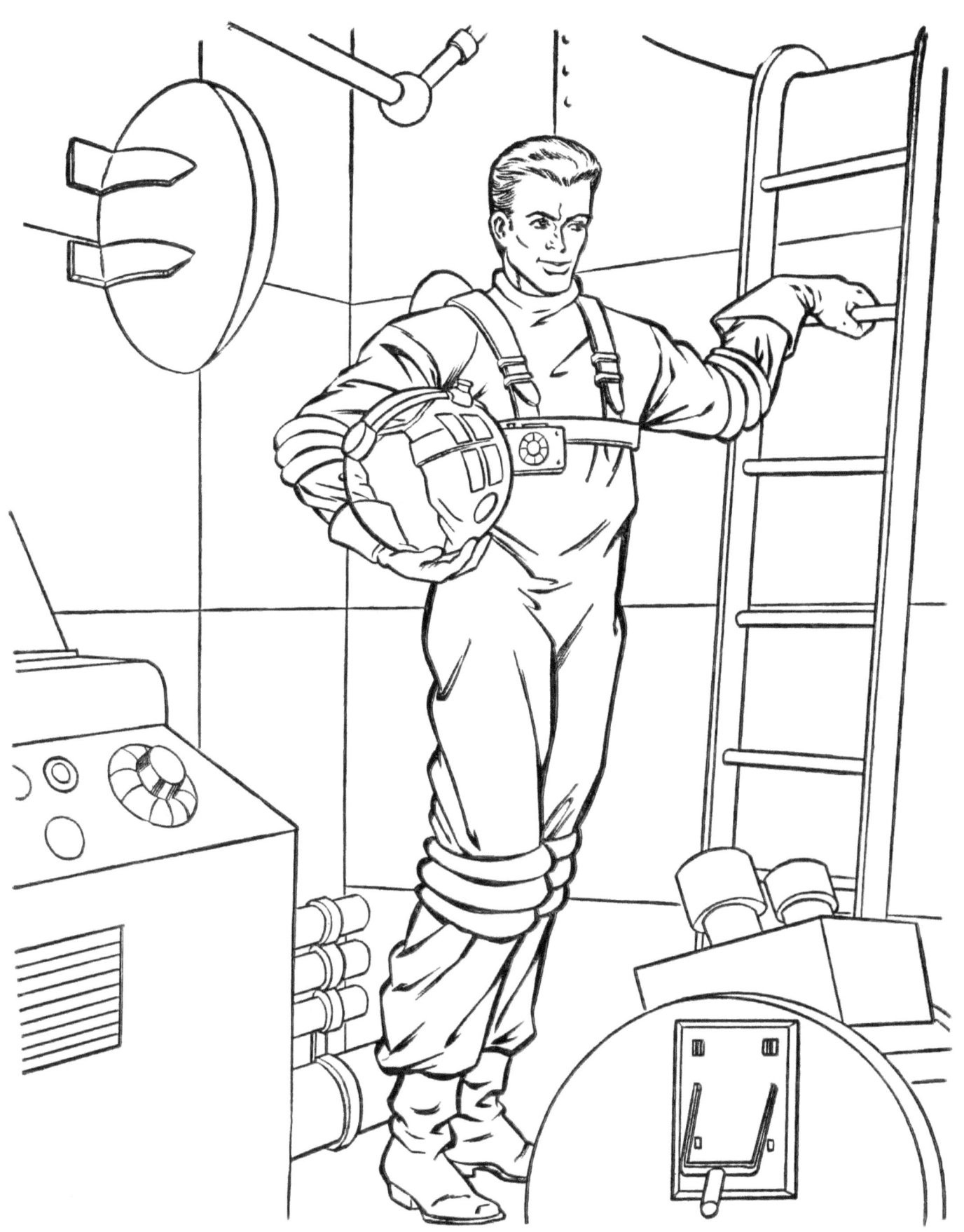

ALFY SPIES A SPACE PIRATE SHIP

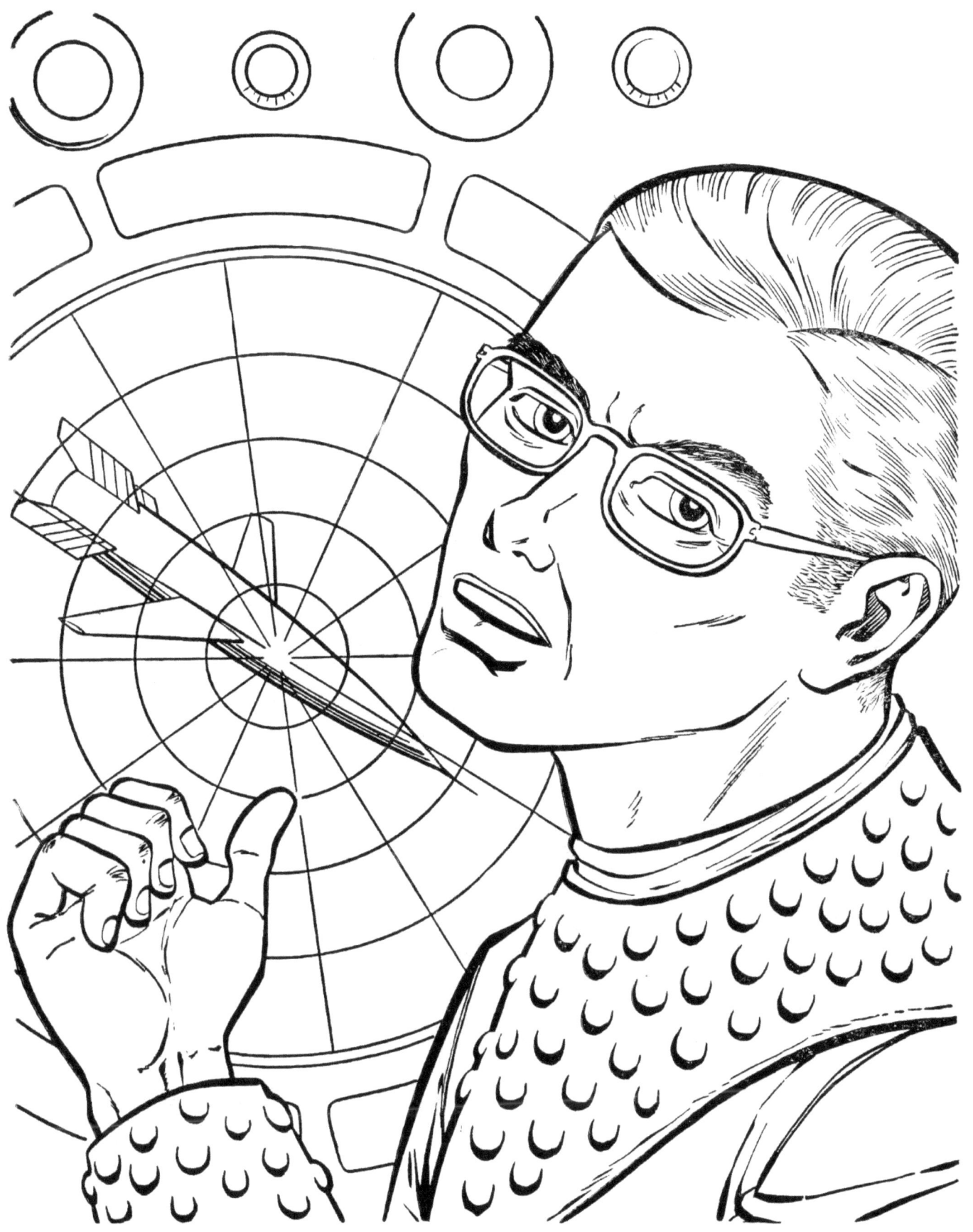

PIRATE SHIP CLOSES IN

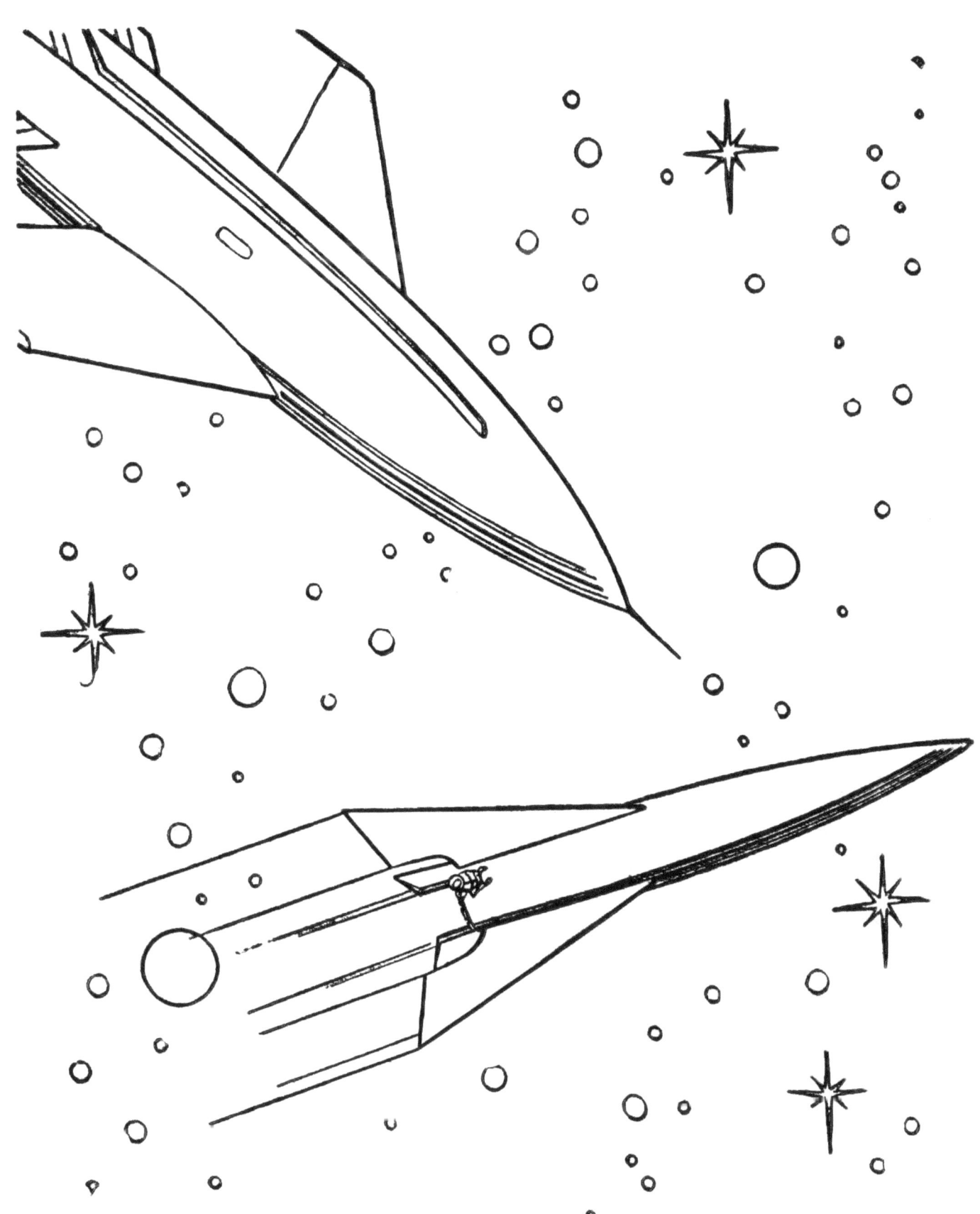

THE PIRATE BRINGS POLARIS INTO VIEW

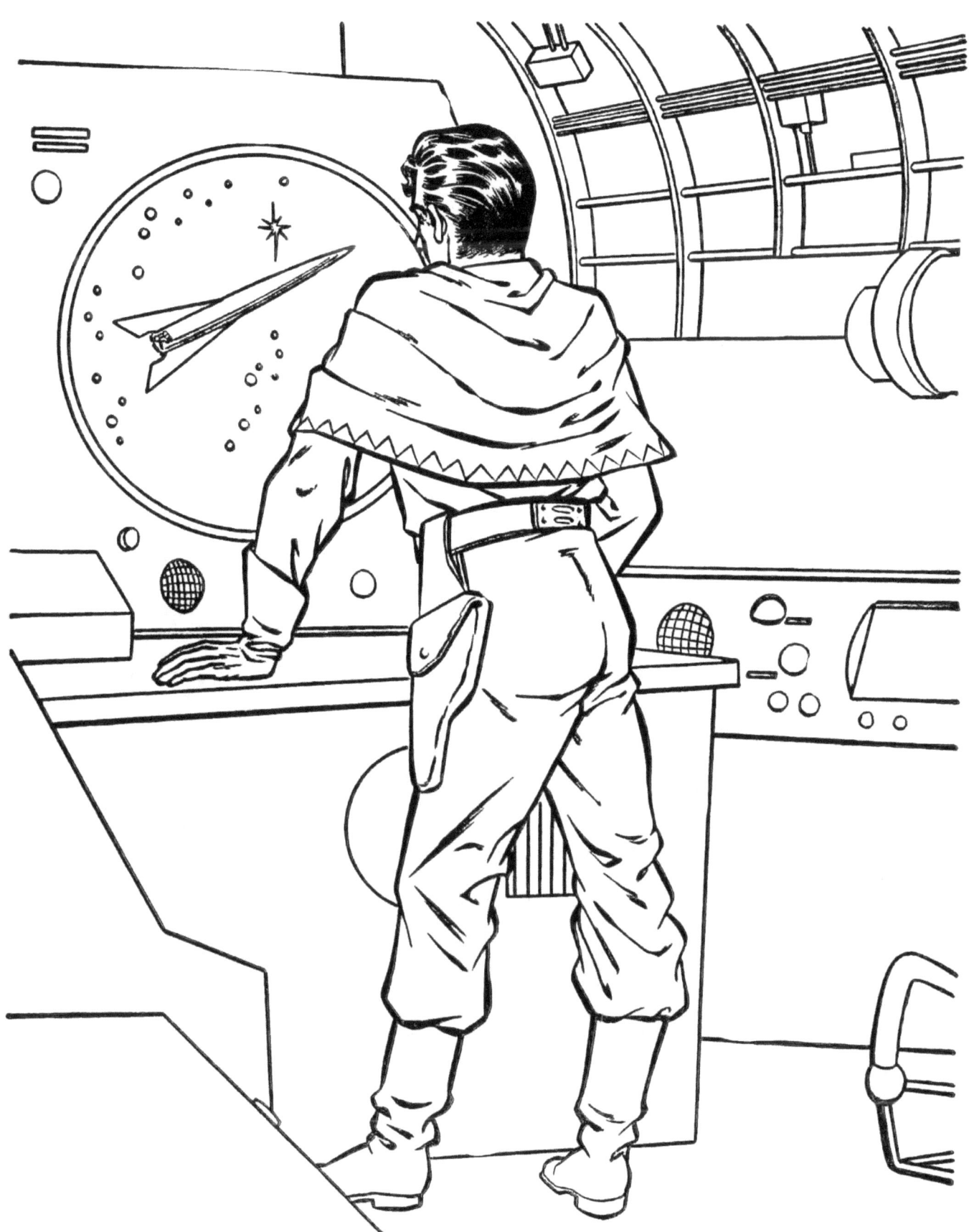

Pirate captain orders super magnet energized

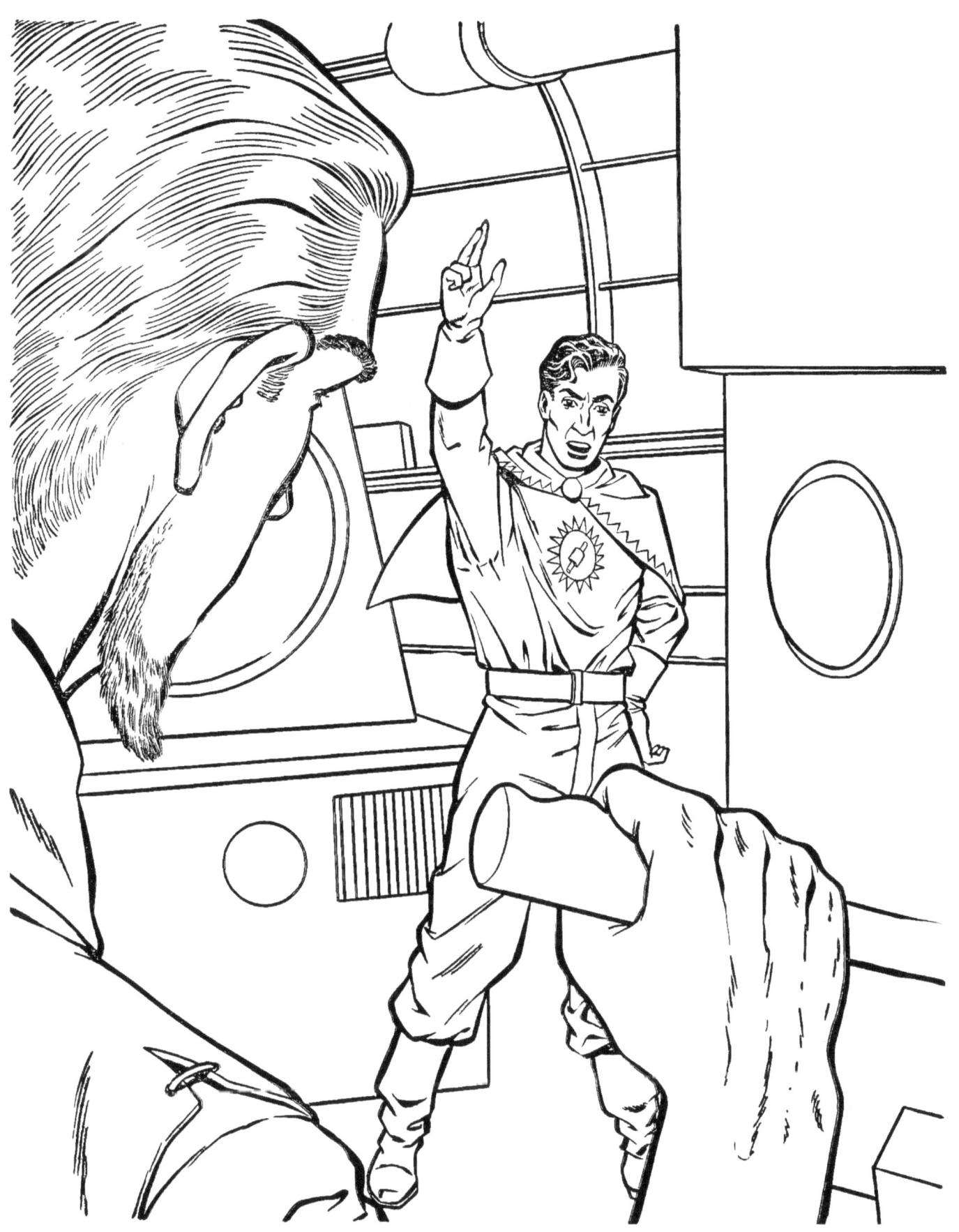

Astro ducks back into Polaris in a hurry

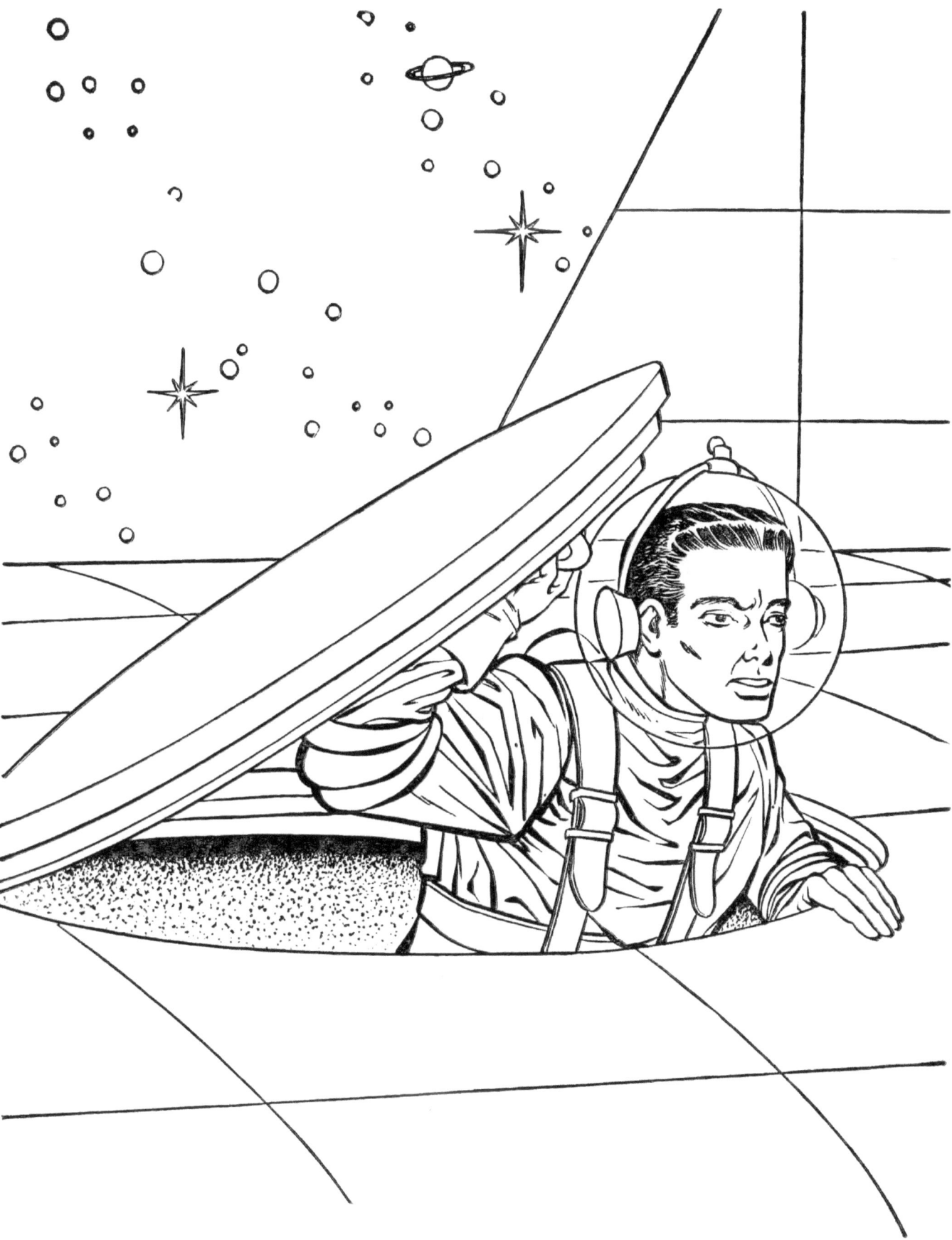

Joan Dale, Tom, and Astro try to escape from the pirates

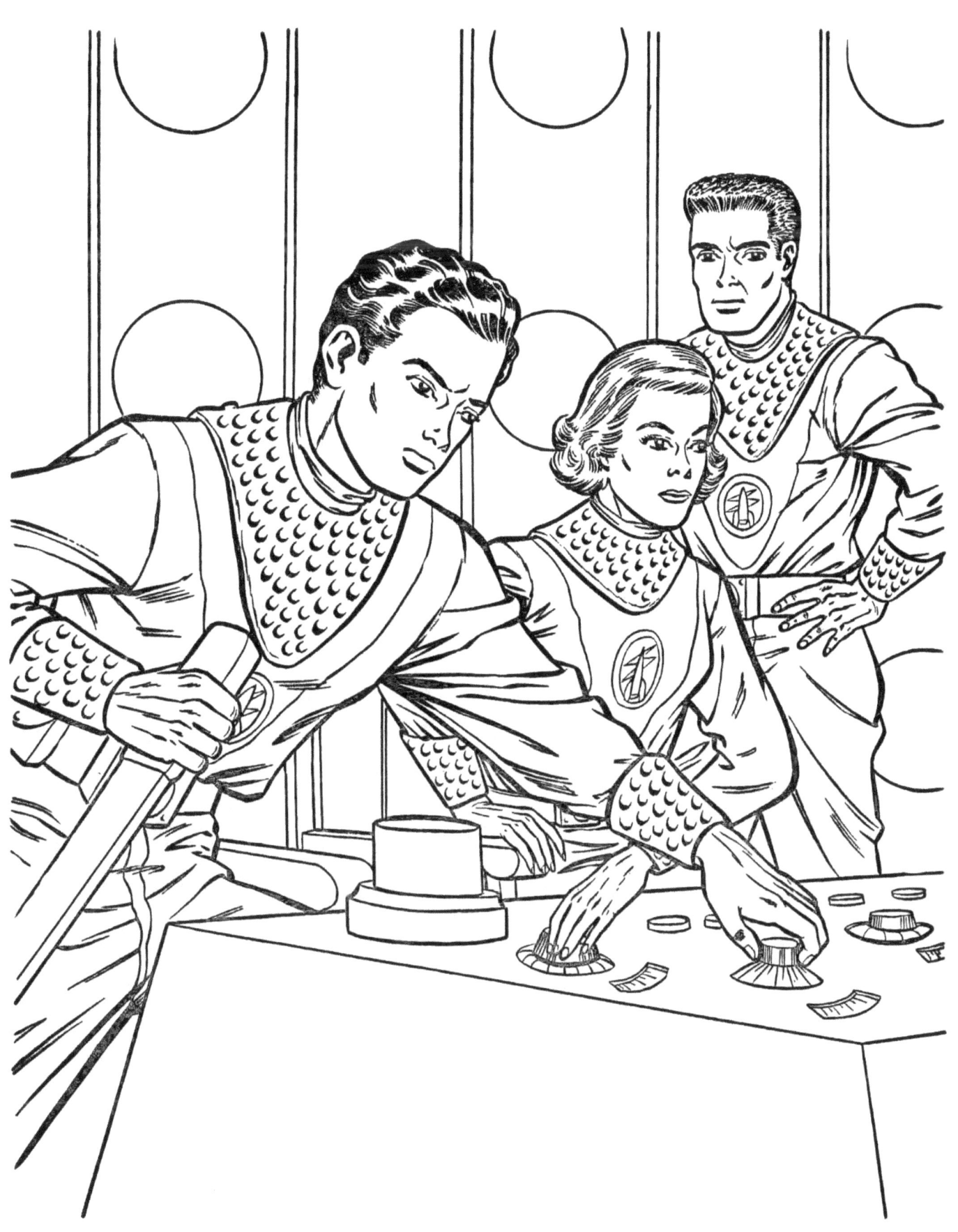

Dr Dale contacts base to warn of trouble

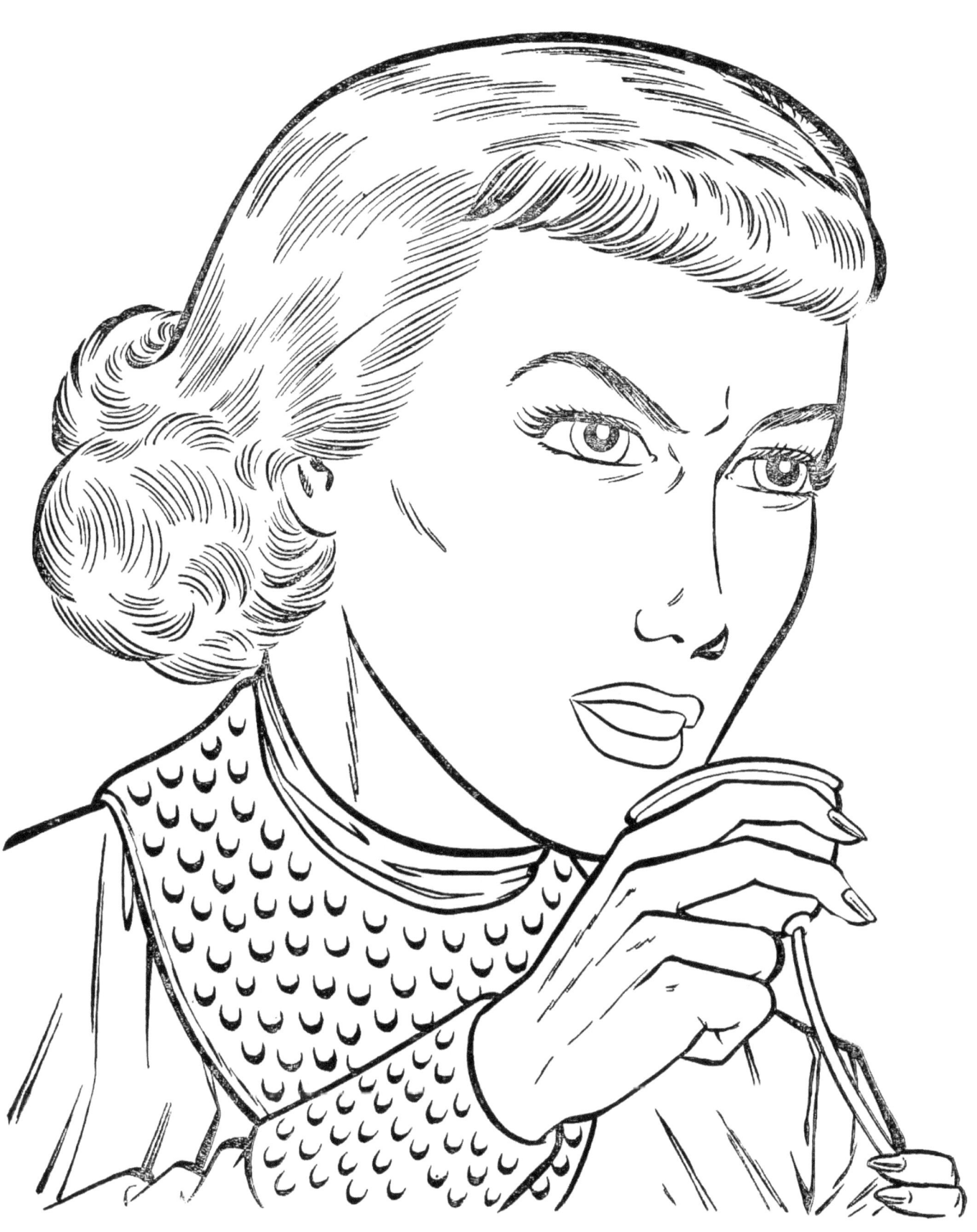

THE PIRATE SHIP FORCES POLARIS DOWN

The Polaris crew discusses the seemingly hopeless problem

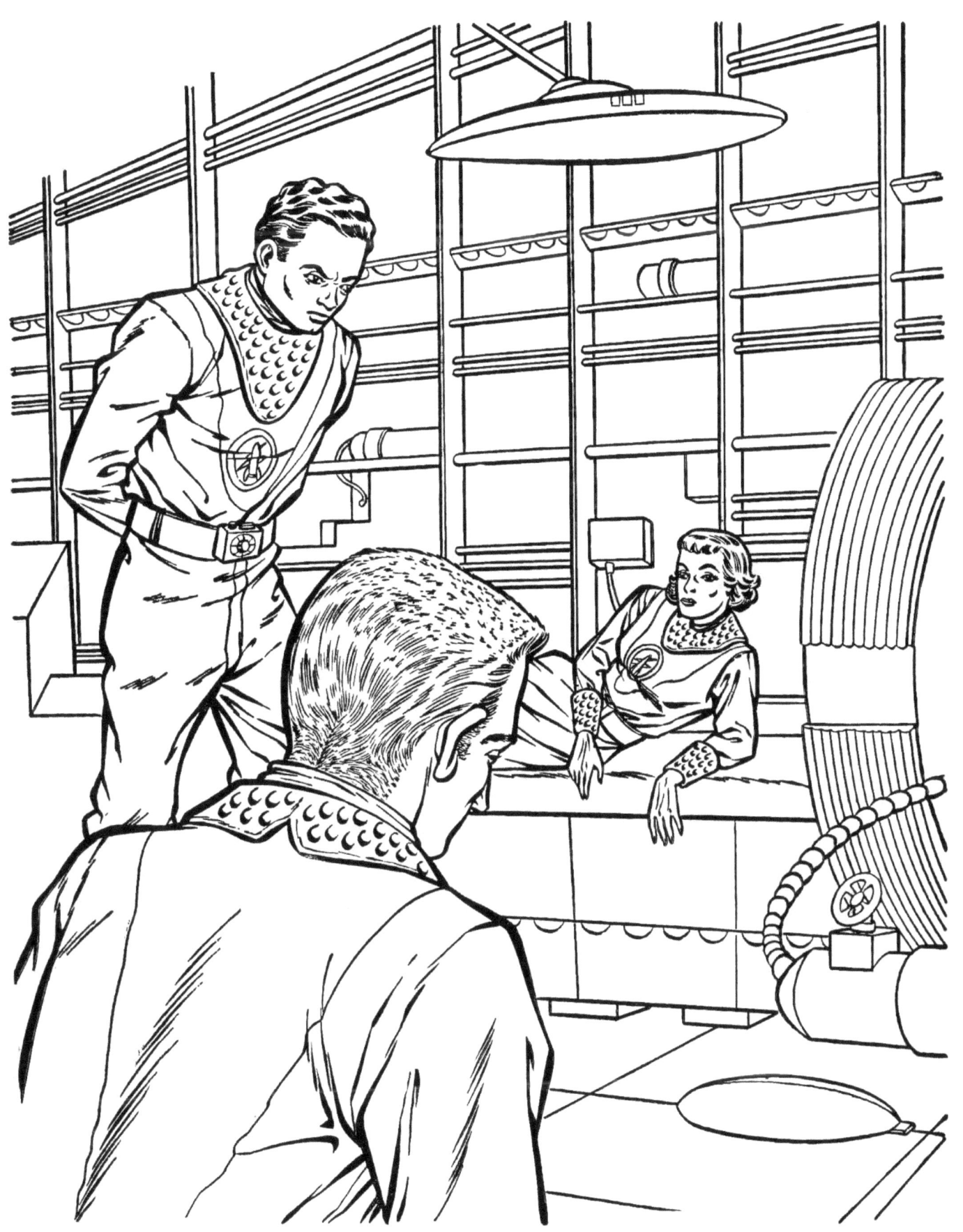

Tom must get a message to land -- or else!

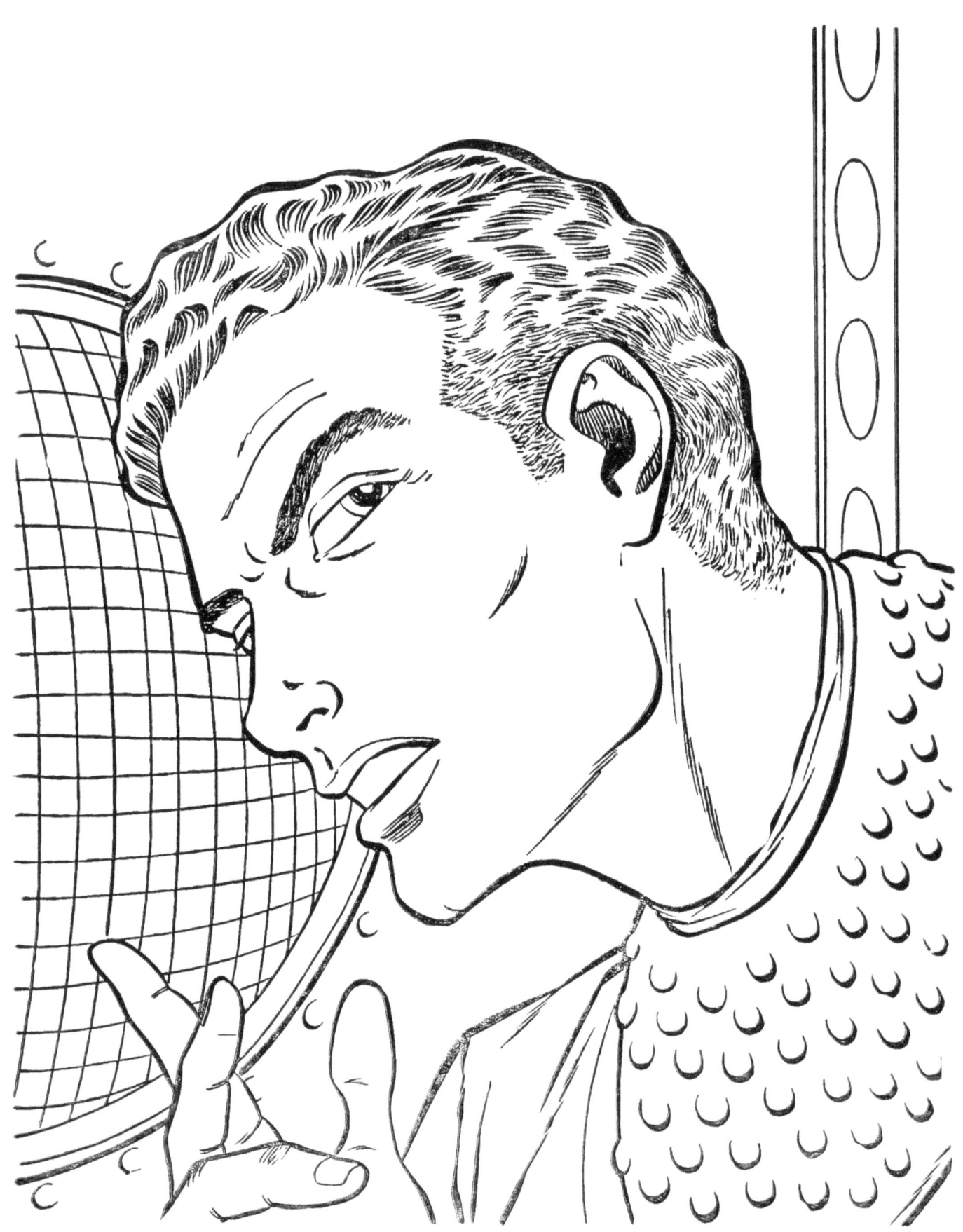

Tom deploys his crew to search for the pirates

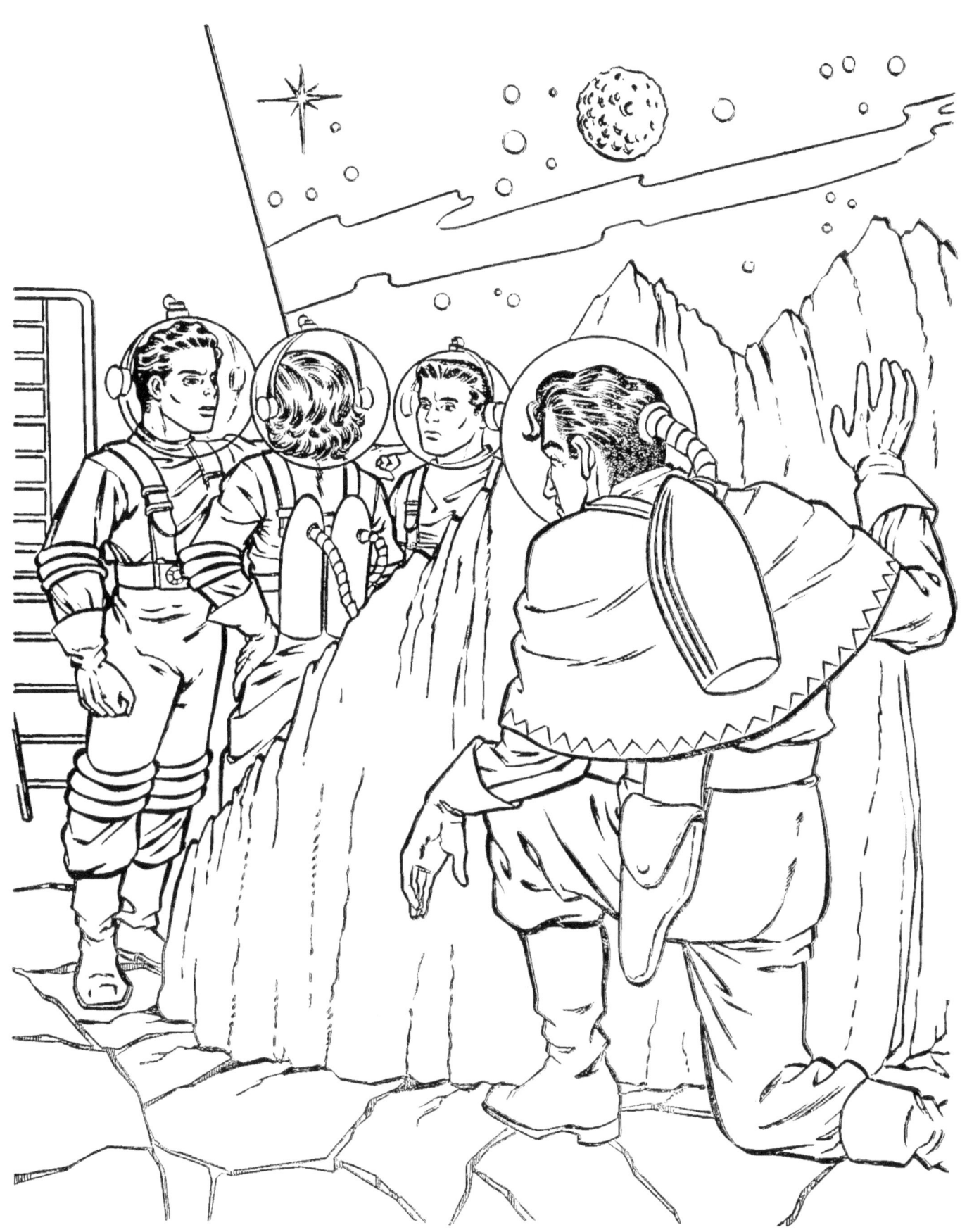

WHILE SEARCHING, TOM HEARS A SCREAM

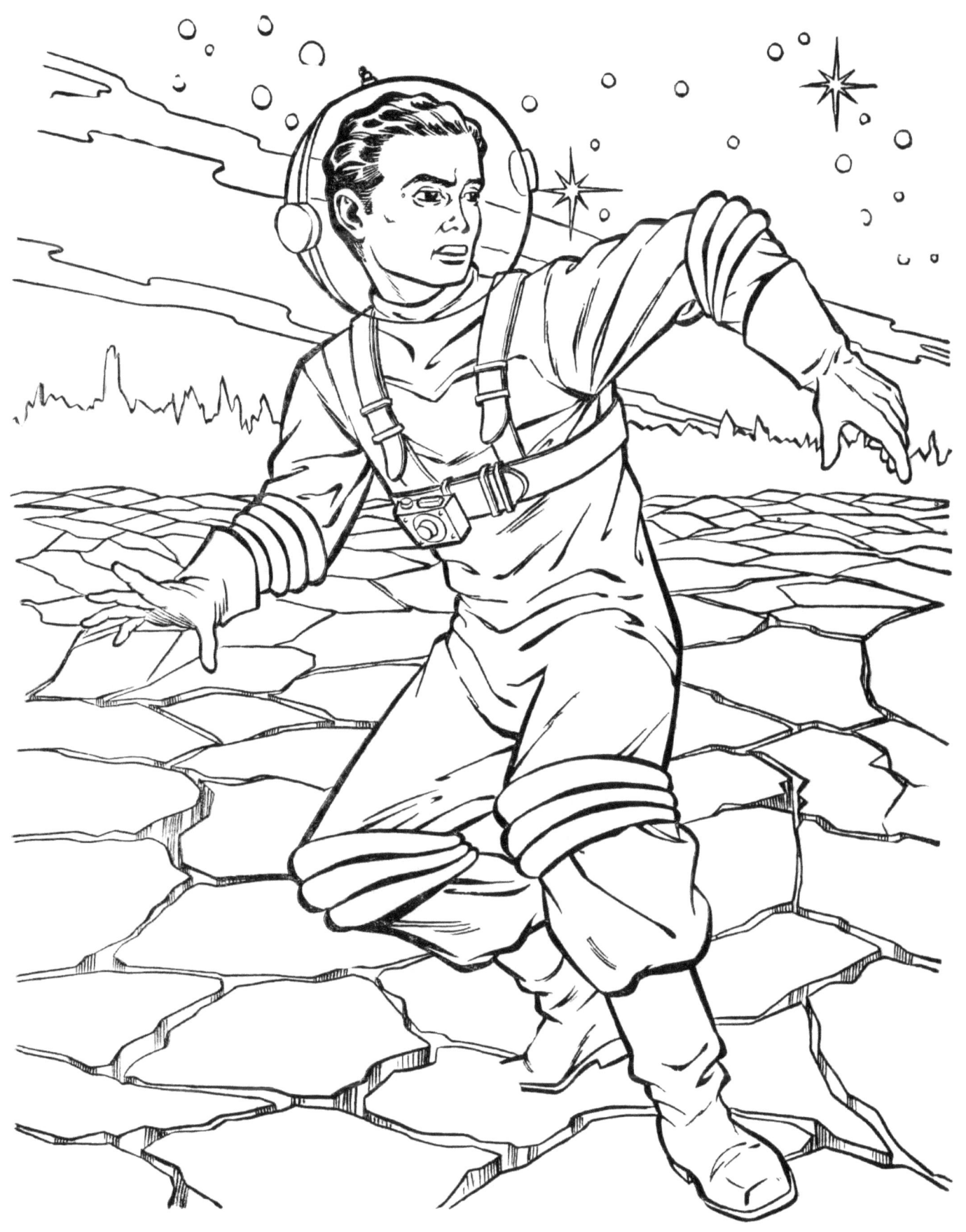

Back at the ship, Tom finds Dr Dole in the clutch of a pirate

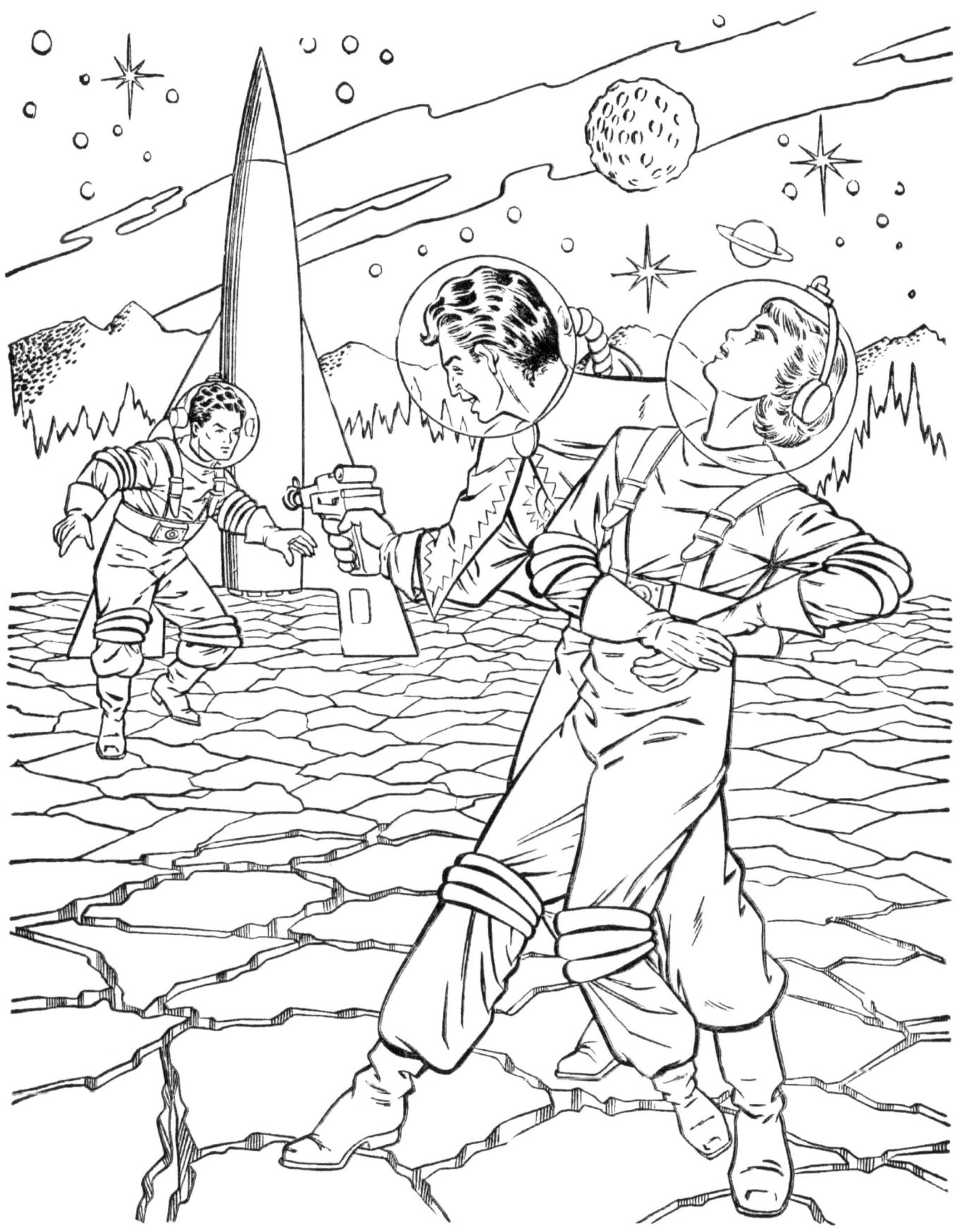

ROGER GOES INTO ACTION

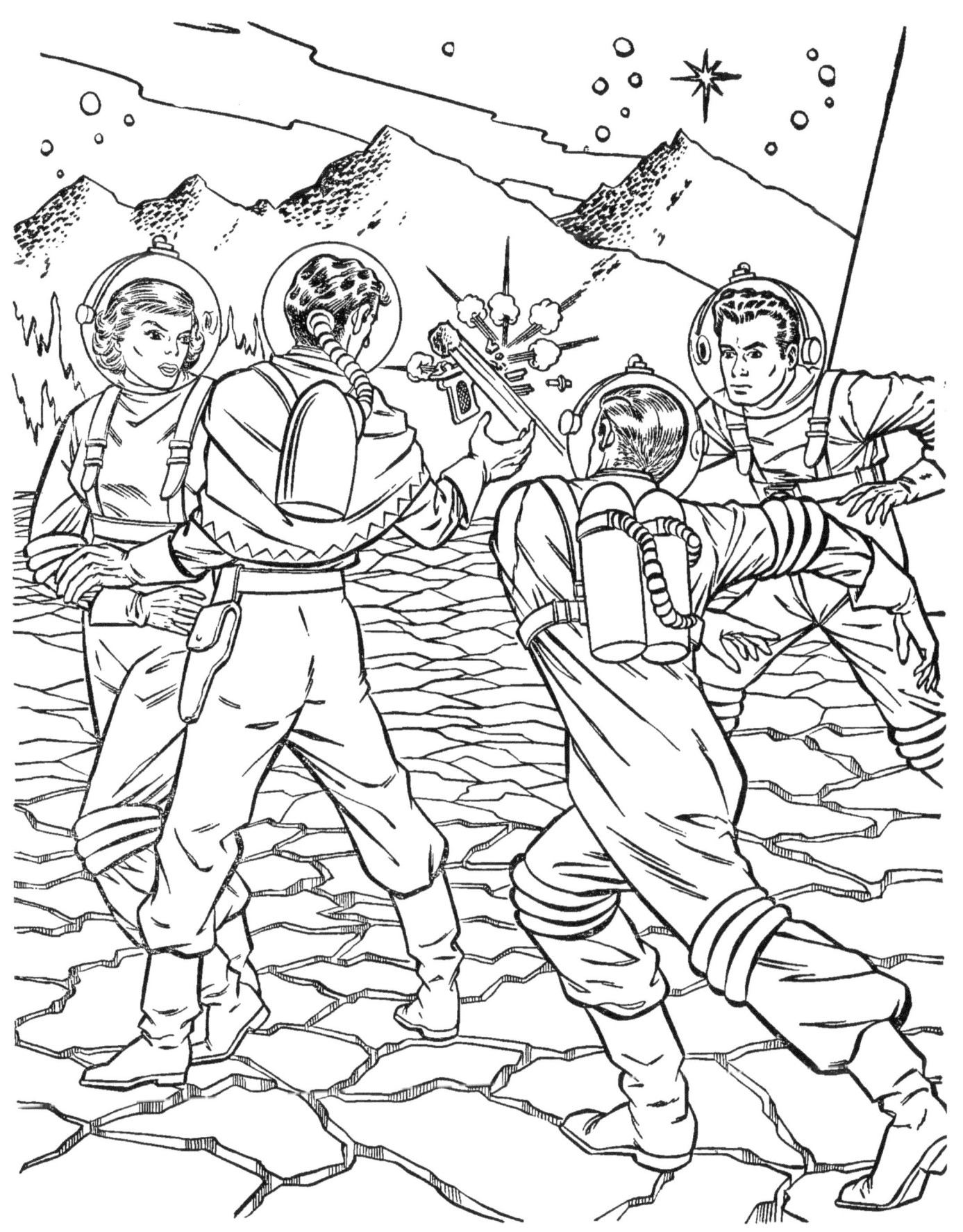

TOM TACKLES THE SPACE PIRATE

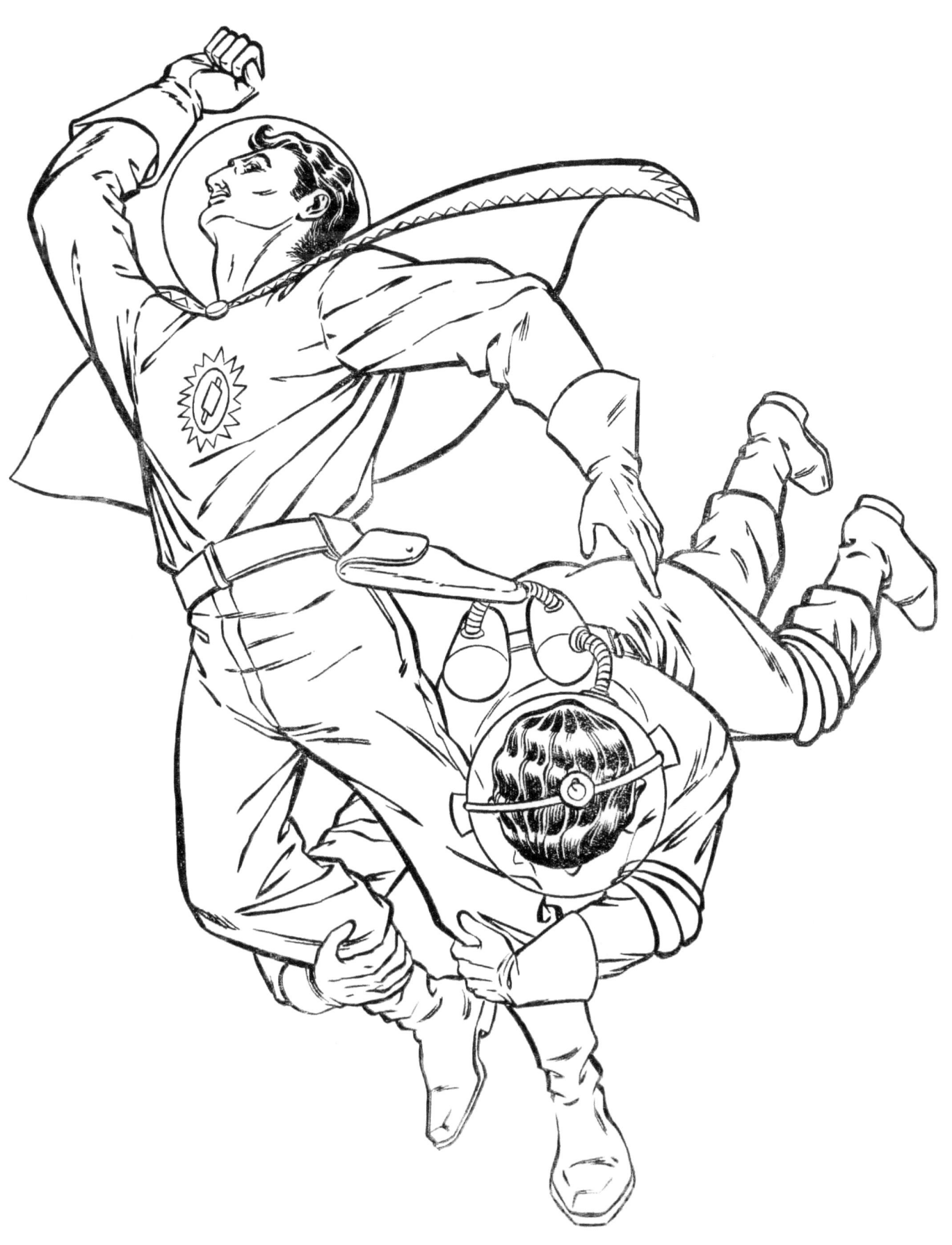

THE PIRATE CAPTAIN IS ARRESTED BY TOM

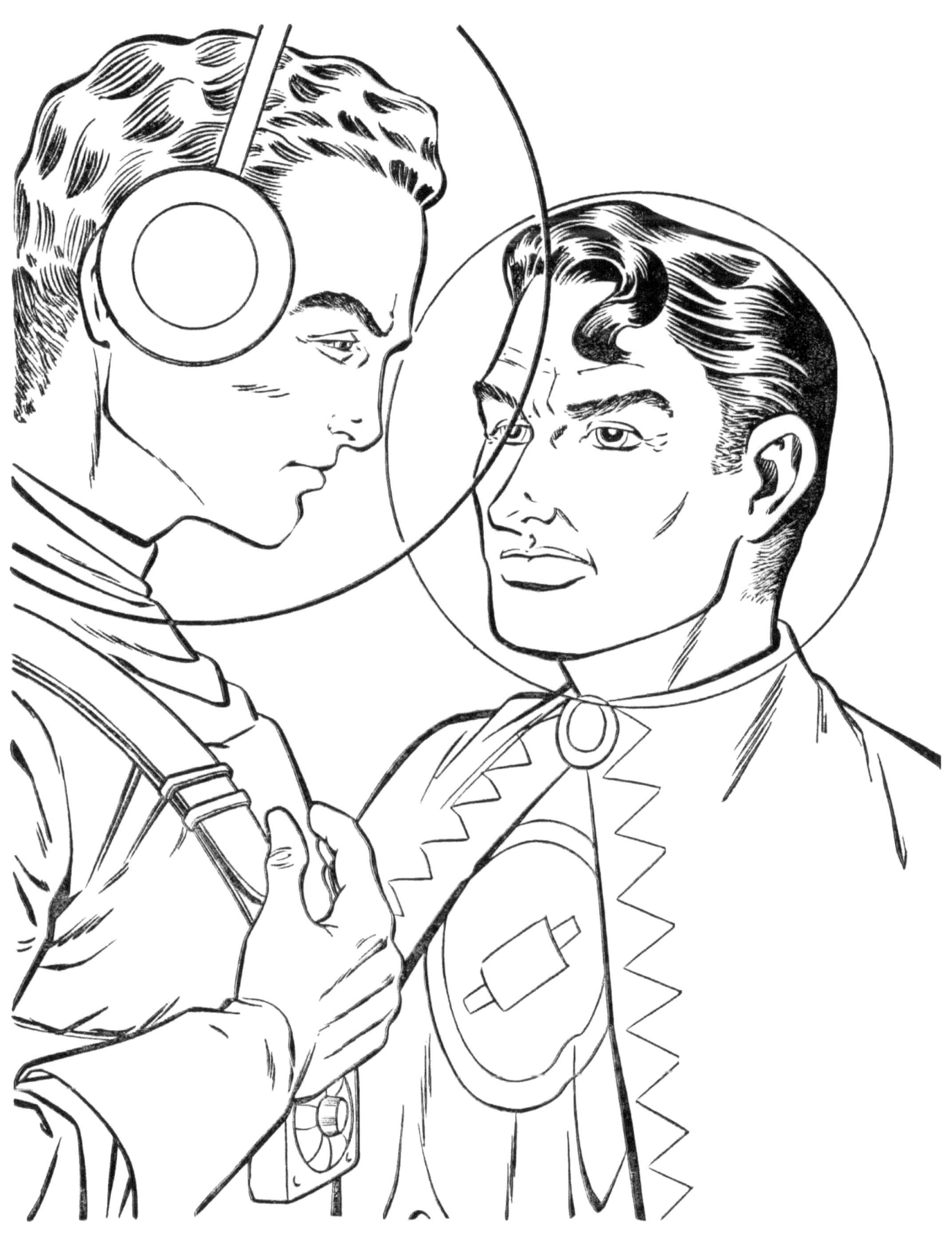

As the pirate ship escapes, Manning yells, "The crew got away!"

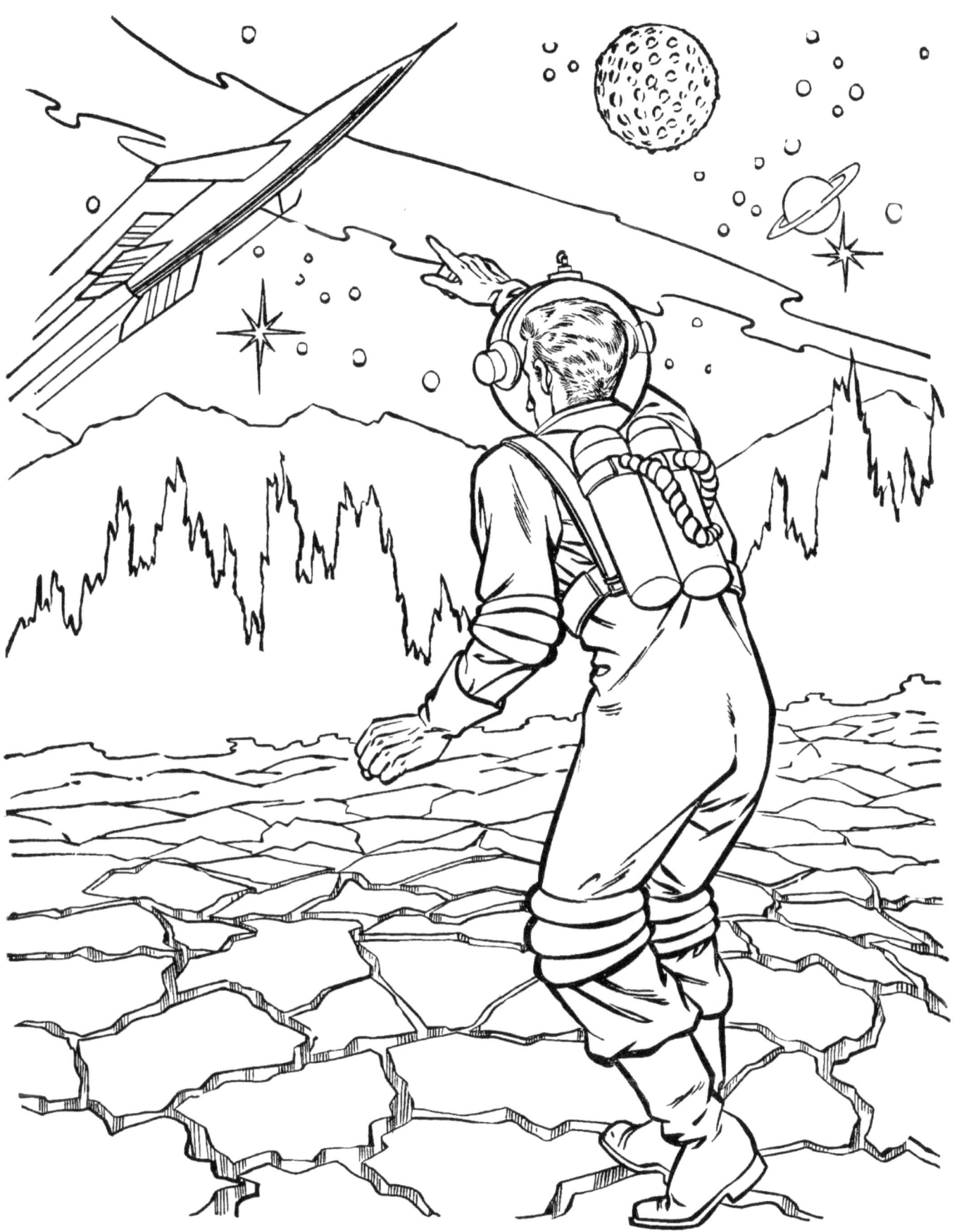

Back in the ship, the Polaris crew decides to continue the scientific mission, and let the Solar Guard take care of the pirates

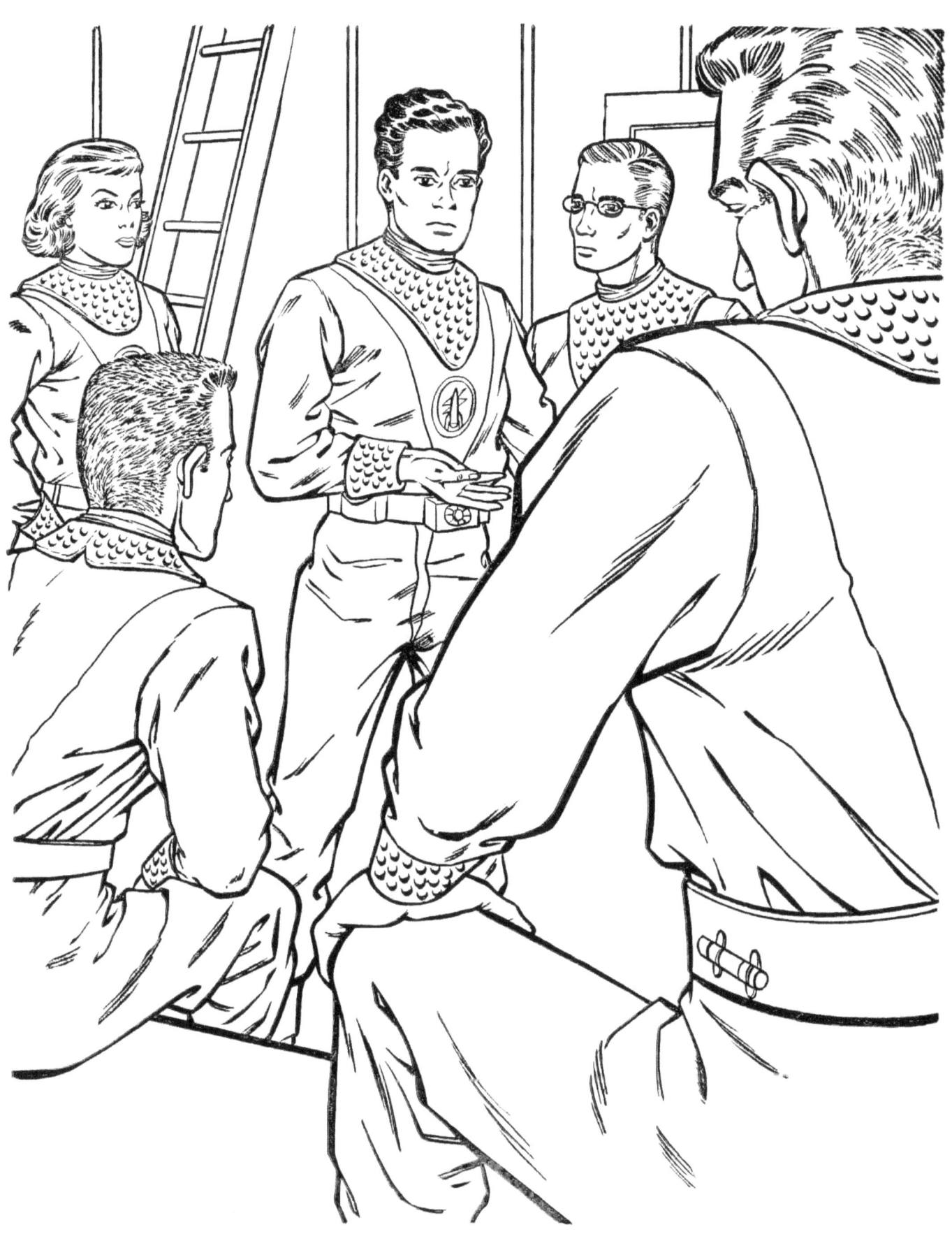

Captain Video receives urgent spacegram informing him high government officials have disappeared, including Earth's ambassador to Saturn. Immediately, Captain Video blasts off from his mountain hideaway to Saturn.

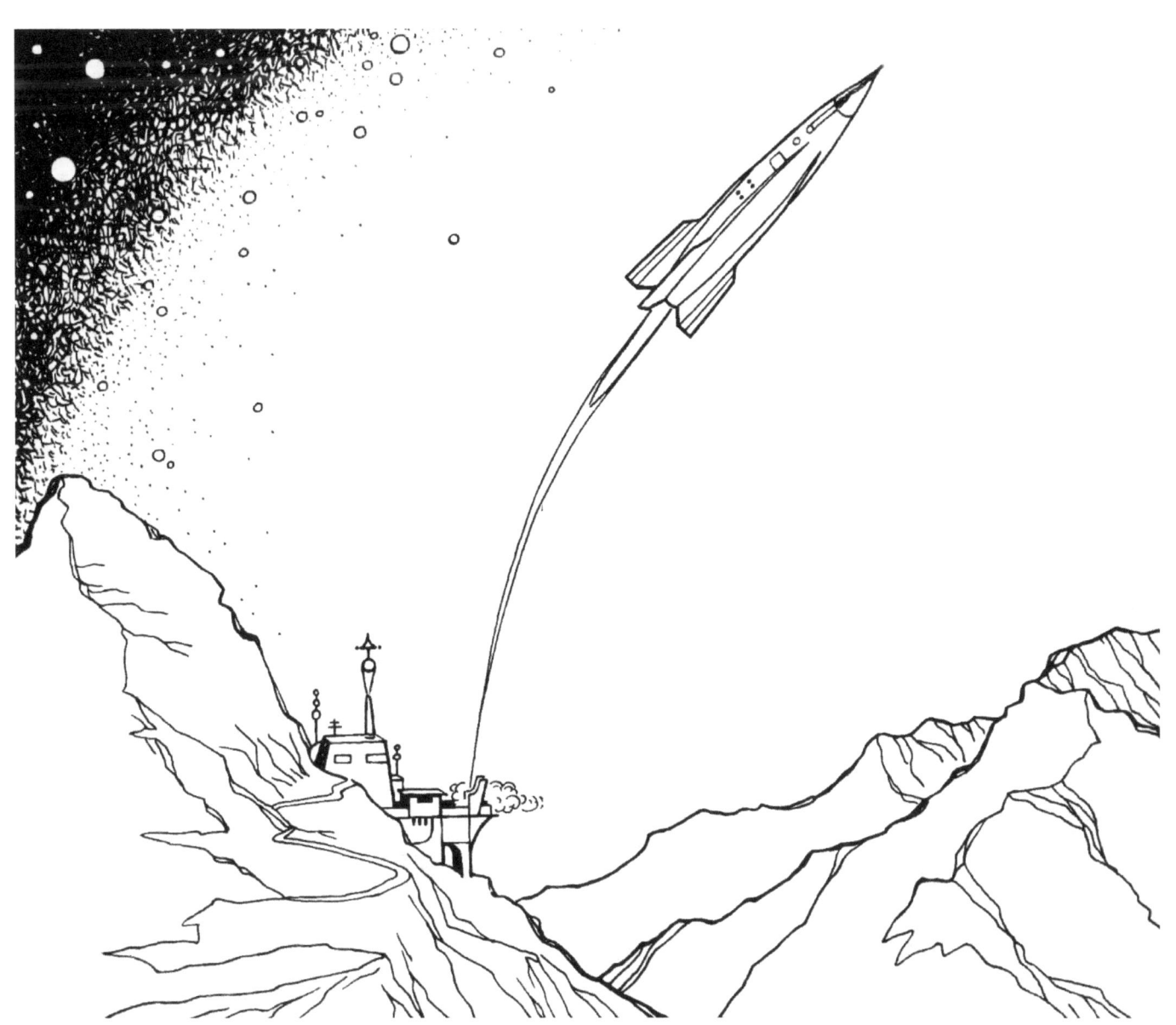

Aboard the "Galaxy," which is Captain Video's space ship, is Commissioner of Public Safety Carey, and the Video Ranger. They rapidly approach Saturn.

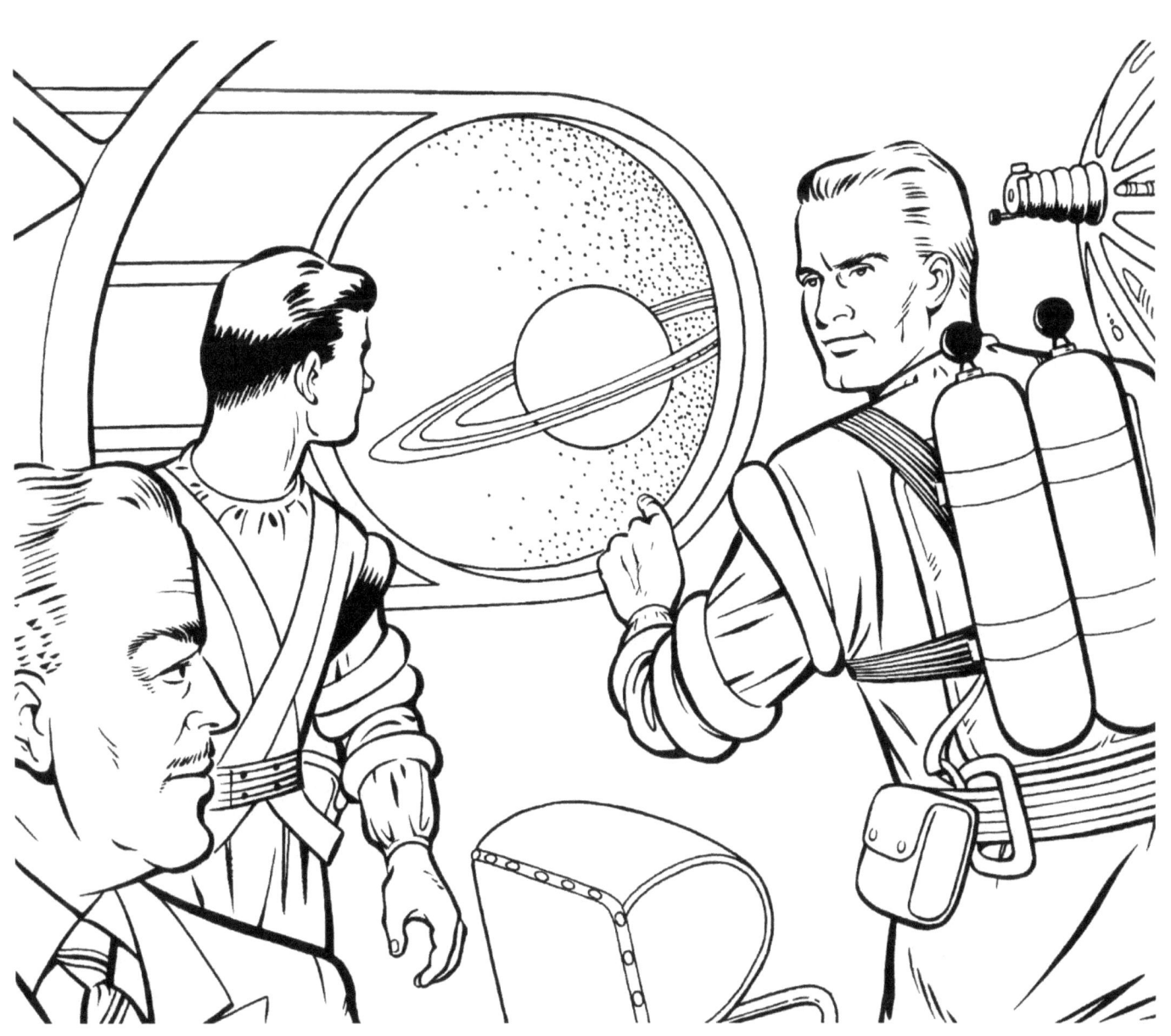

Once near Saturn, they are forced to land when the "Galaxy" is hit by a space torpedo. Captain Video is then confronted by a masked man who says his name is Mentor and claims to be the ruler of Saturn.

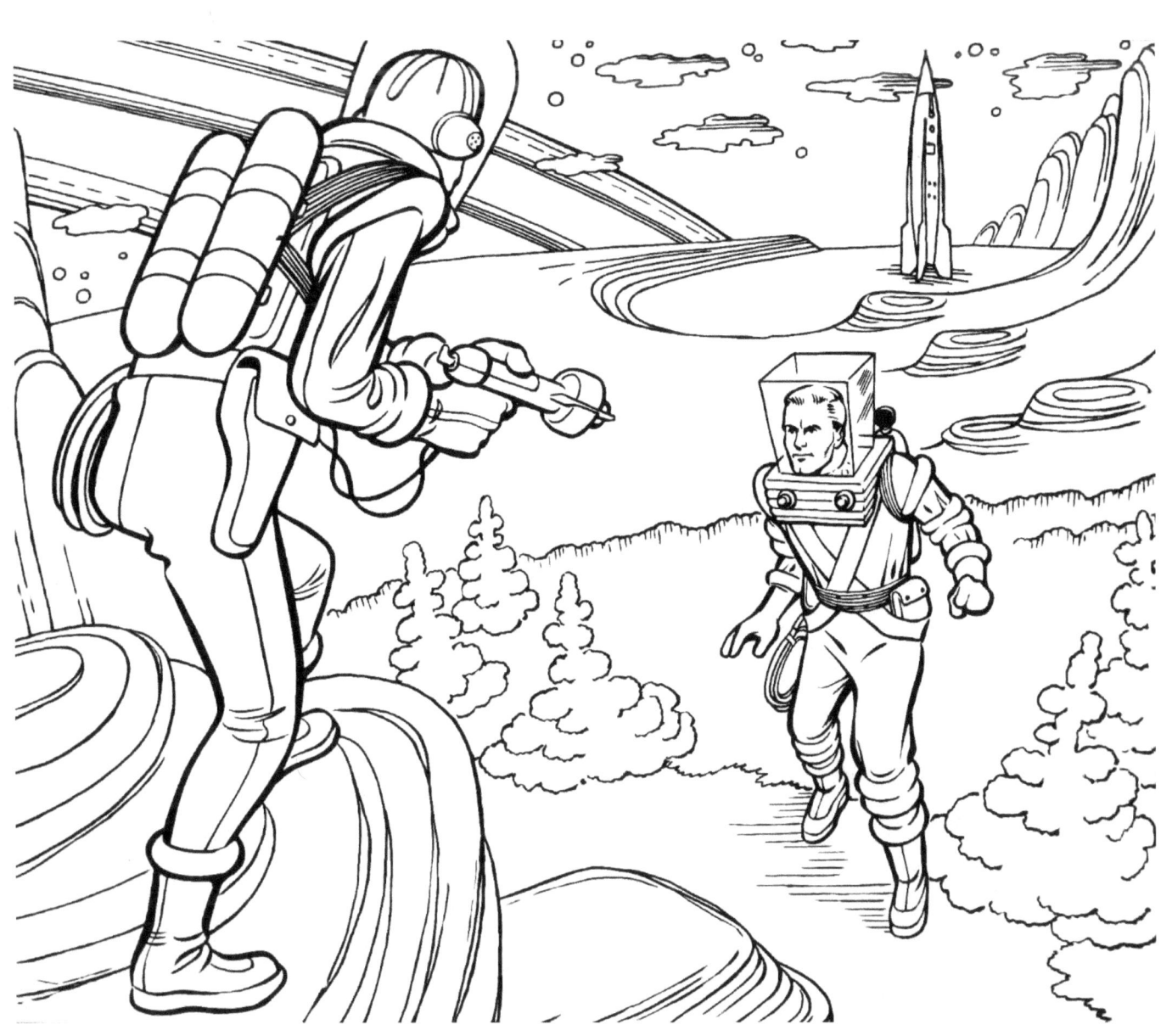

The inhabitants of Saturn are ignorant savages over whom Mentor has complete control. However, Mentor is powerless when the savages run in fear as they are "divebombed" by a space jeep.

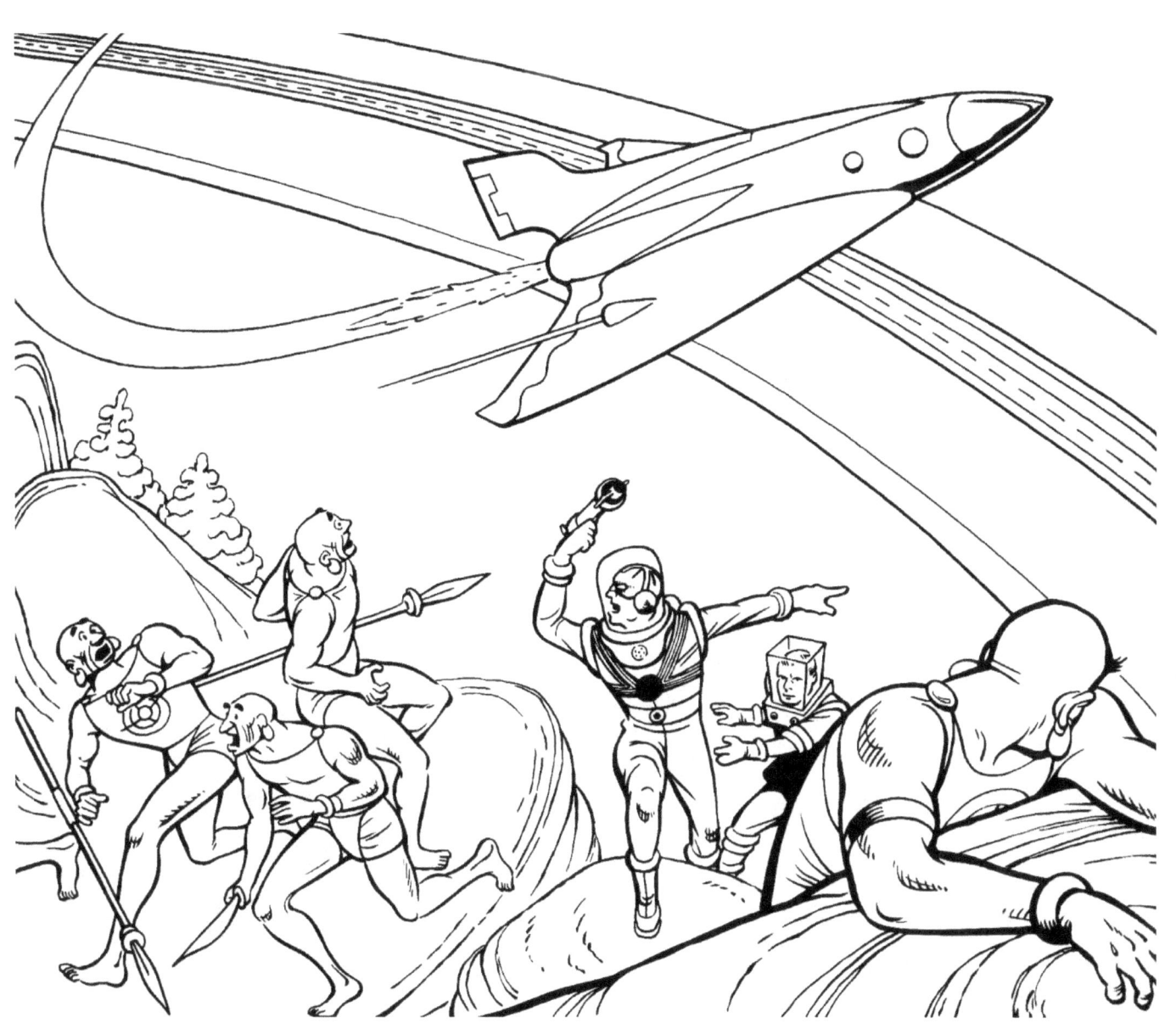

The space jeep is driven by the Video Ranger. In the confusion that follows, Captain Video overpowers Mentor.

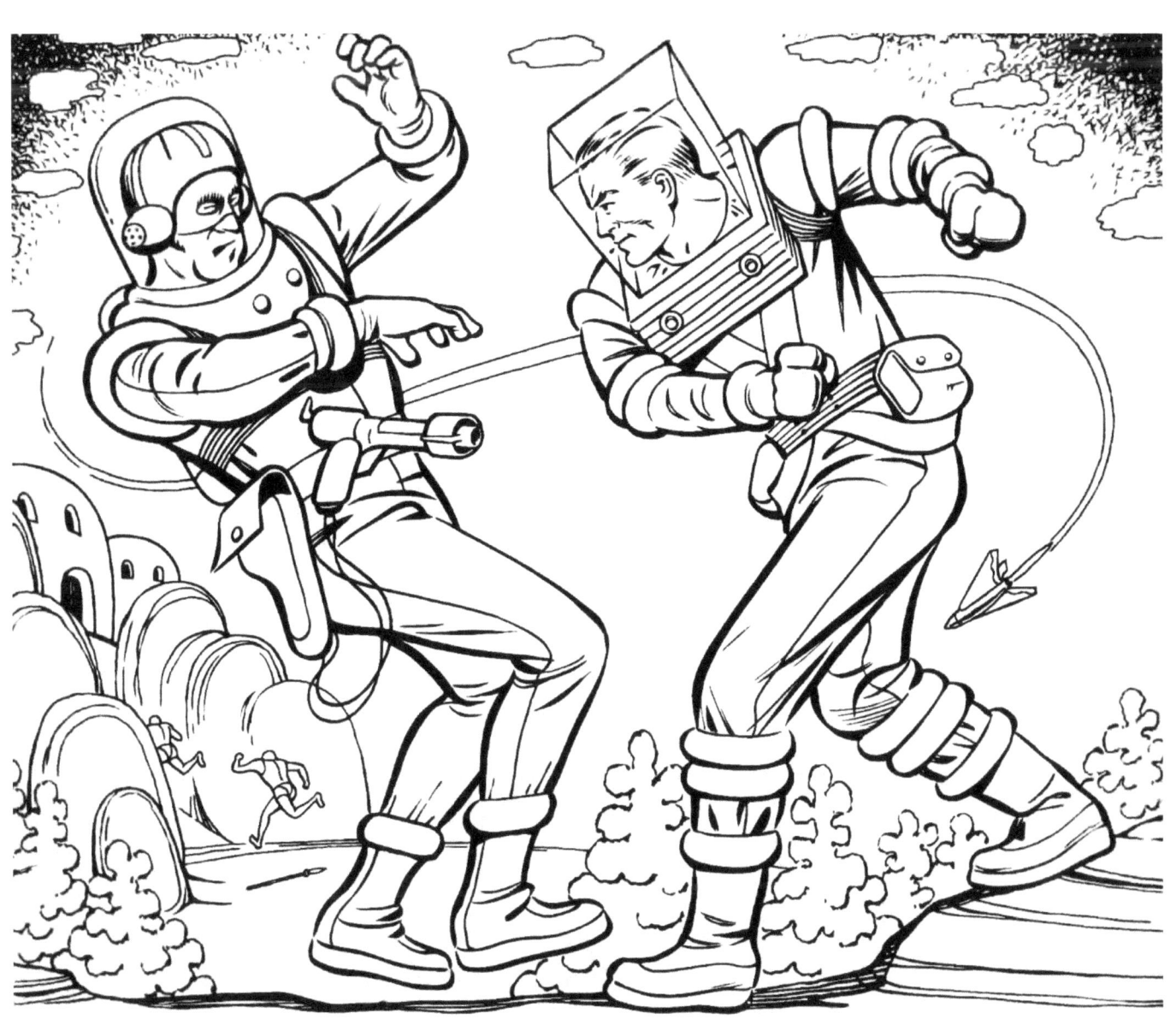

Mentor turns out to be Charles Henderson, Earth's ambassador to Saturn. Henderson has kidnapped government officials to control the entire Solar System.

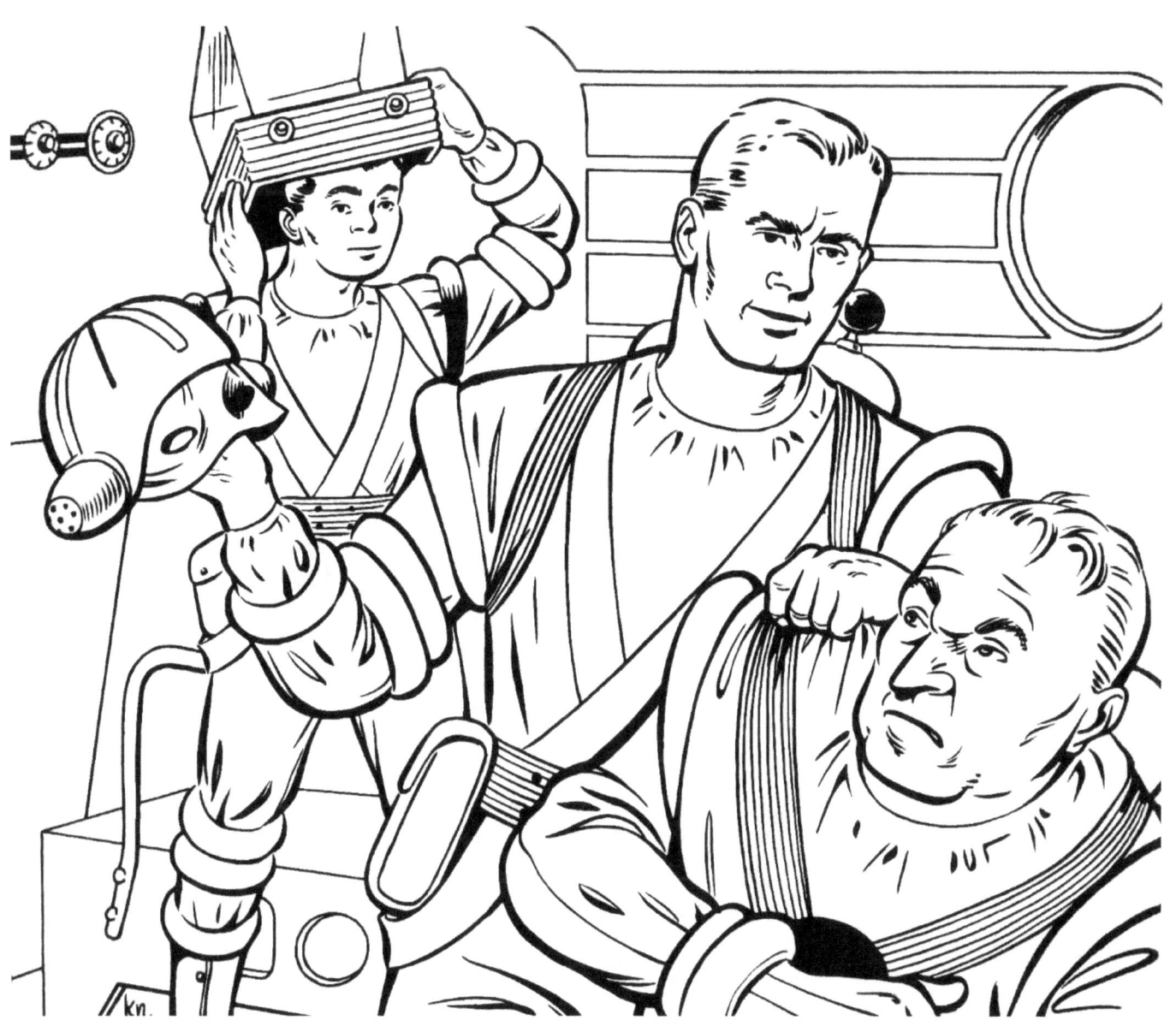

Captain Video rescues the officials. Now the Solar System is safe for the time being.

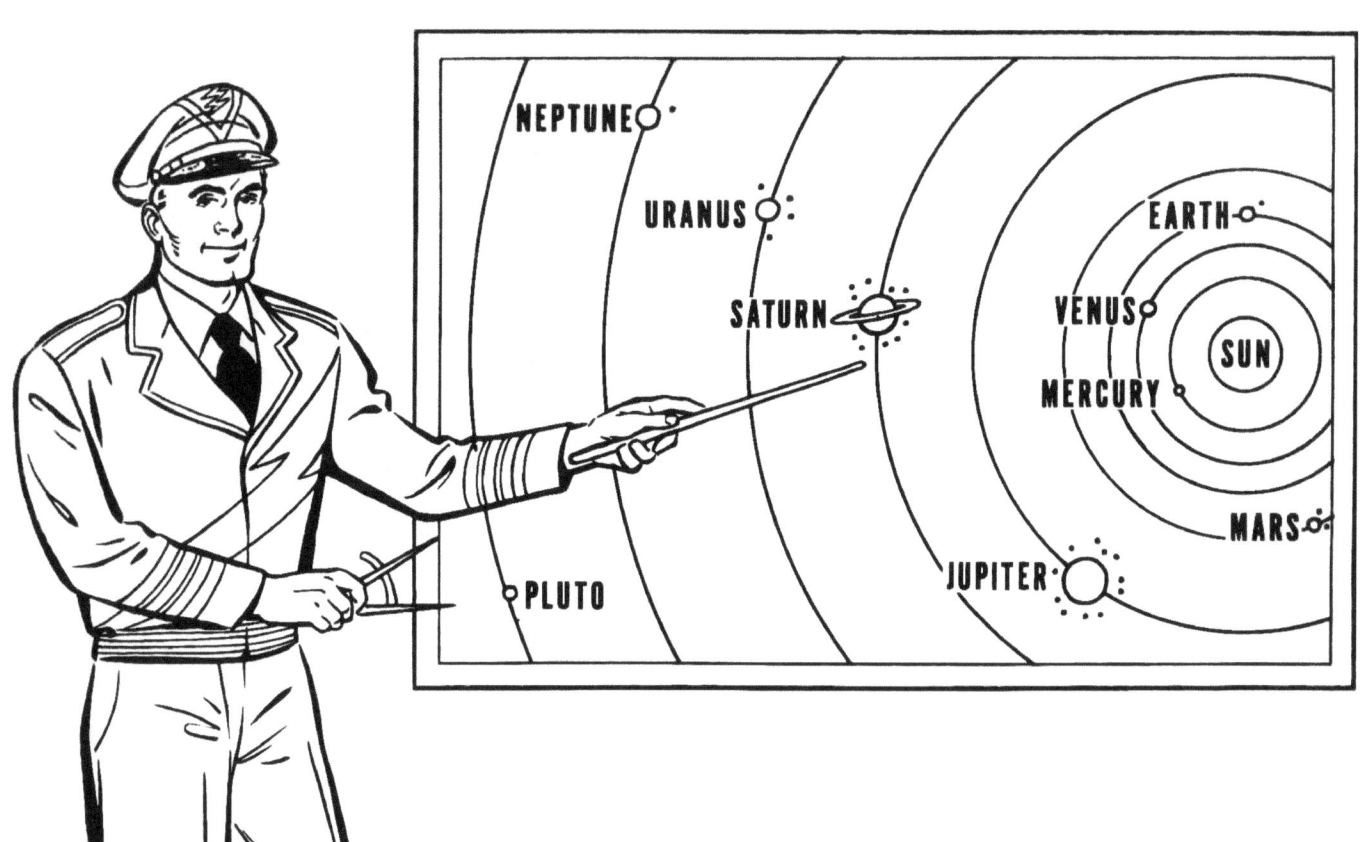

Captain Video is informed by Commissioner of Public Safety Carey that he is to move an arch criminal named Octavo and his accomplice named Finch from the Moon to a penal colony near Jupiter.

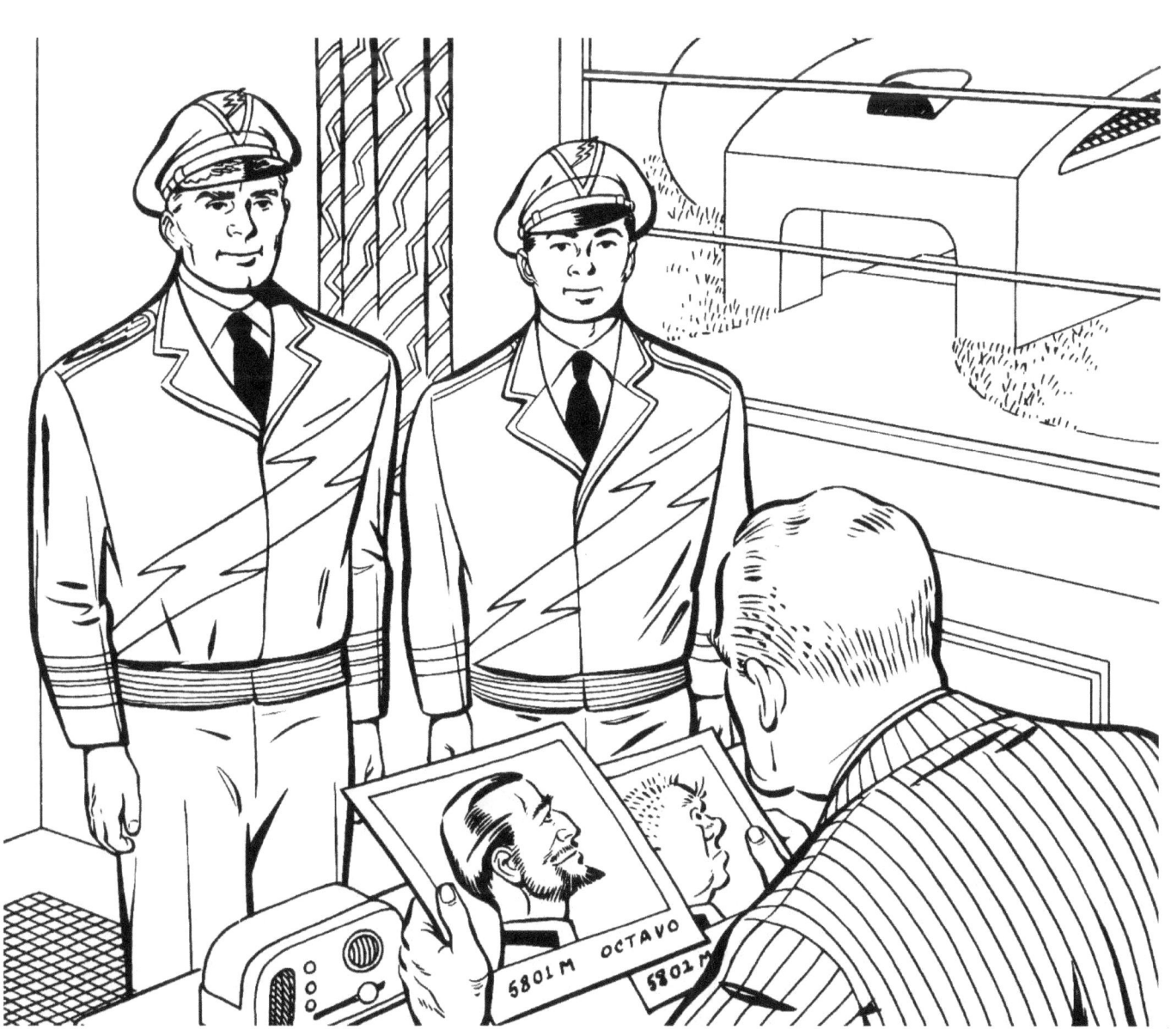

After picking up Octavo and Finch, Captain Video heads his space ship, the "Galaxy" toward Jupiter. On the way, the "Galaxy" is pelted by meteor rock.

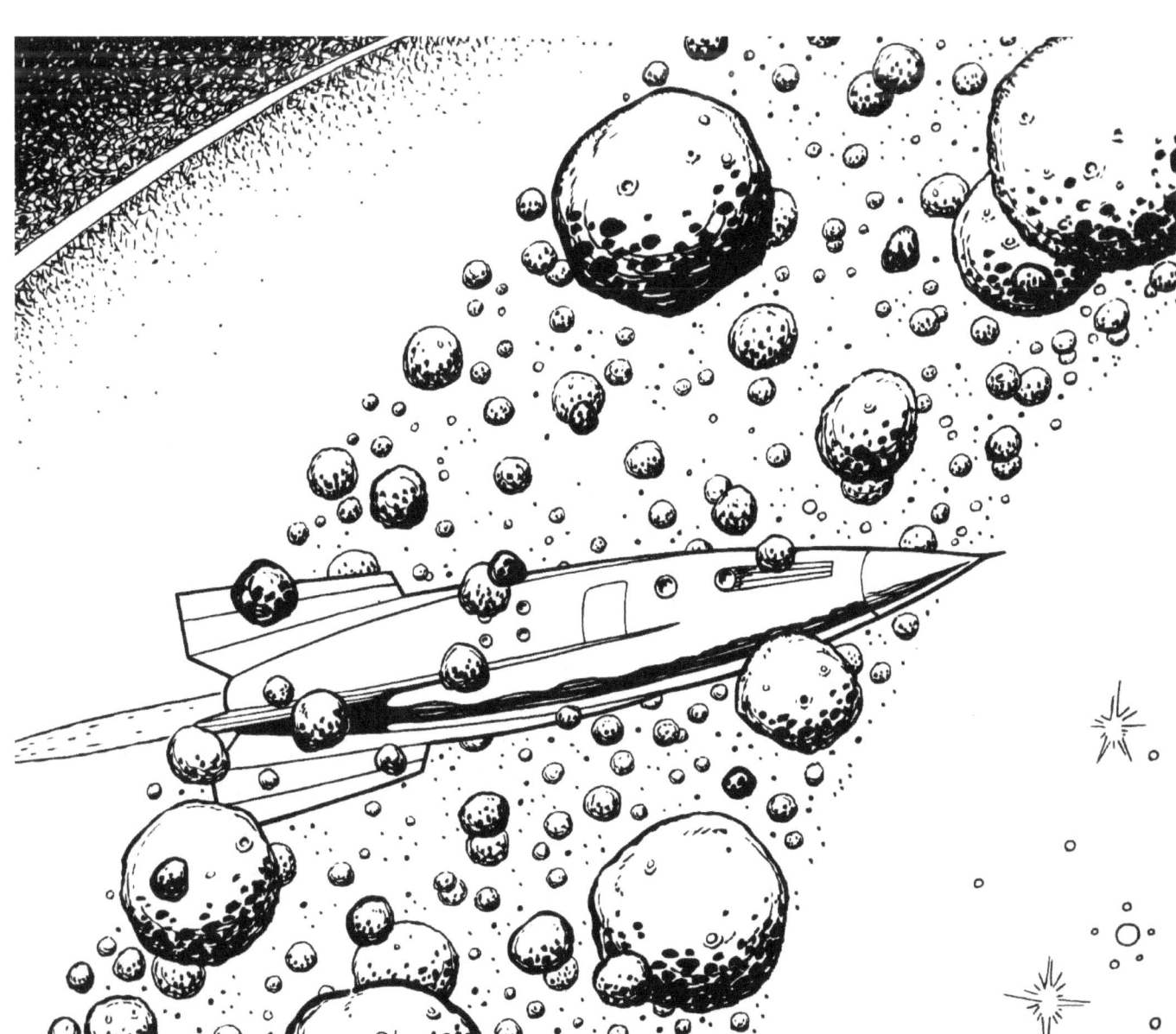

When Captain Video and the Video Ranger climb out of the ship to check damages, Octavo and Finch try to start up the "Galaxy."

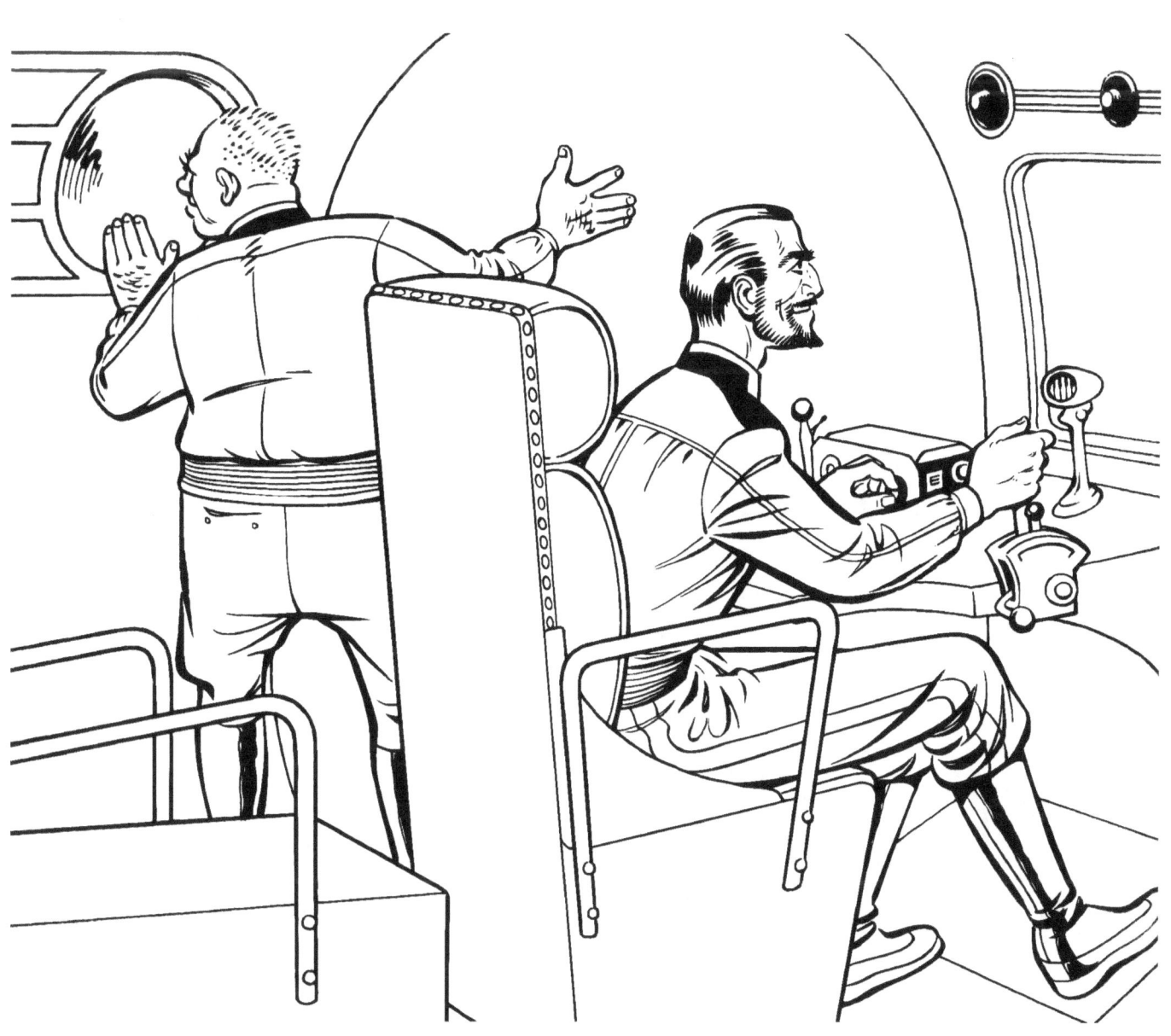

The "Galaxy" starts to move, almost leaving the Ranger behind in space, but Captain Video throws the Ranger a lifeline just in time.

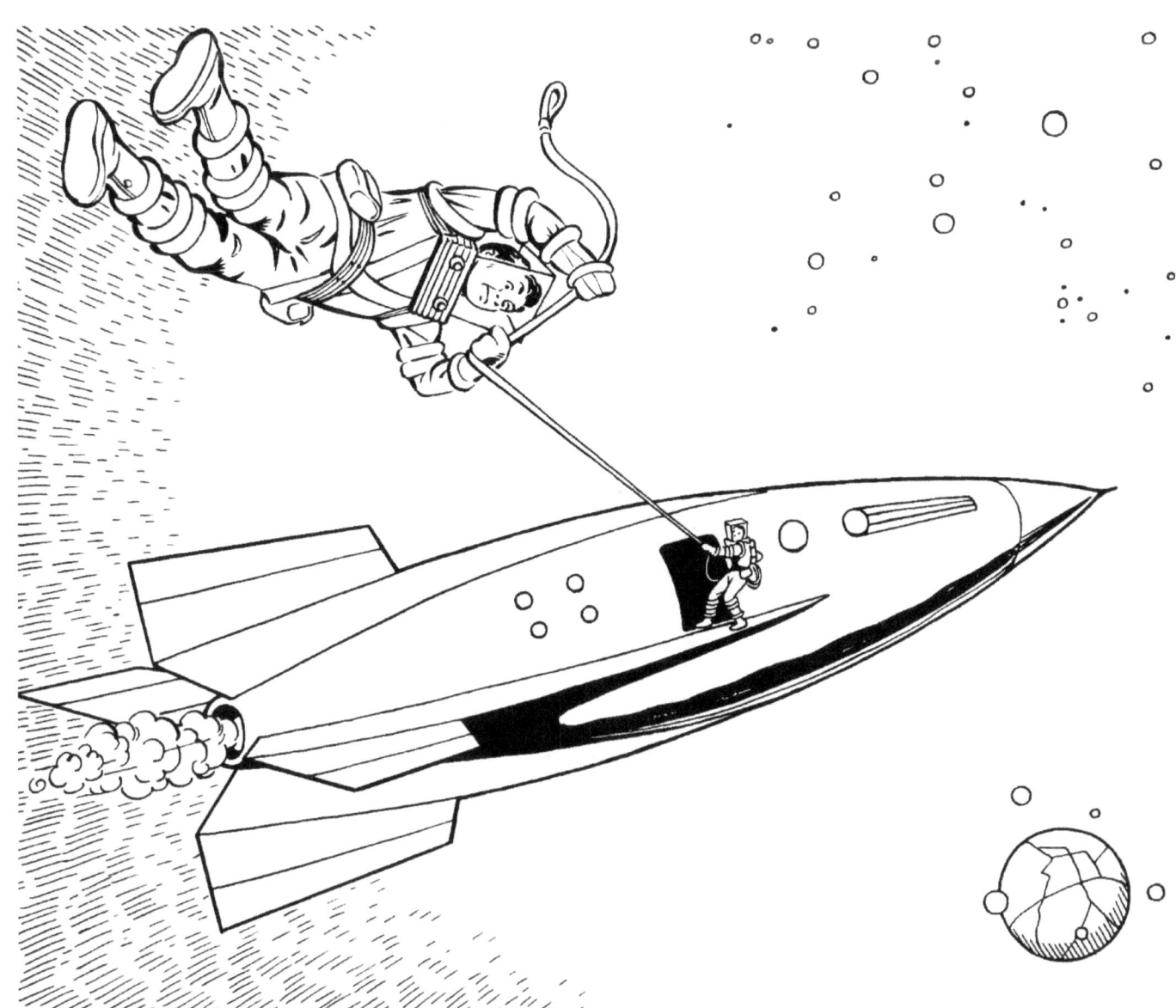

Back inside the "Galaxy," Octavo attacks Video and the Ranger with a space-pick, but Captain Video outsmarts Octavo.

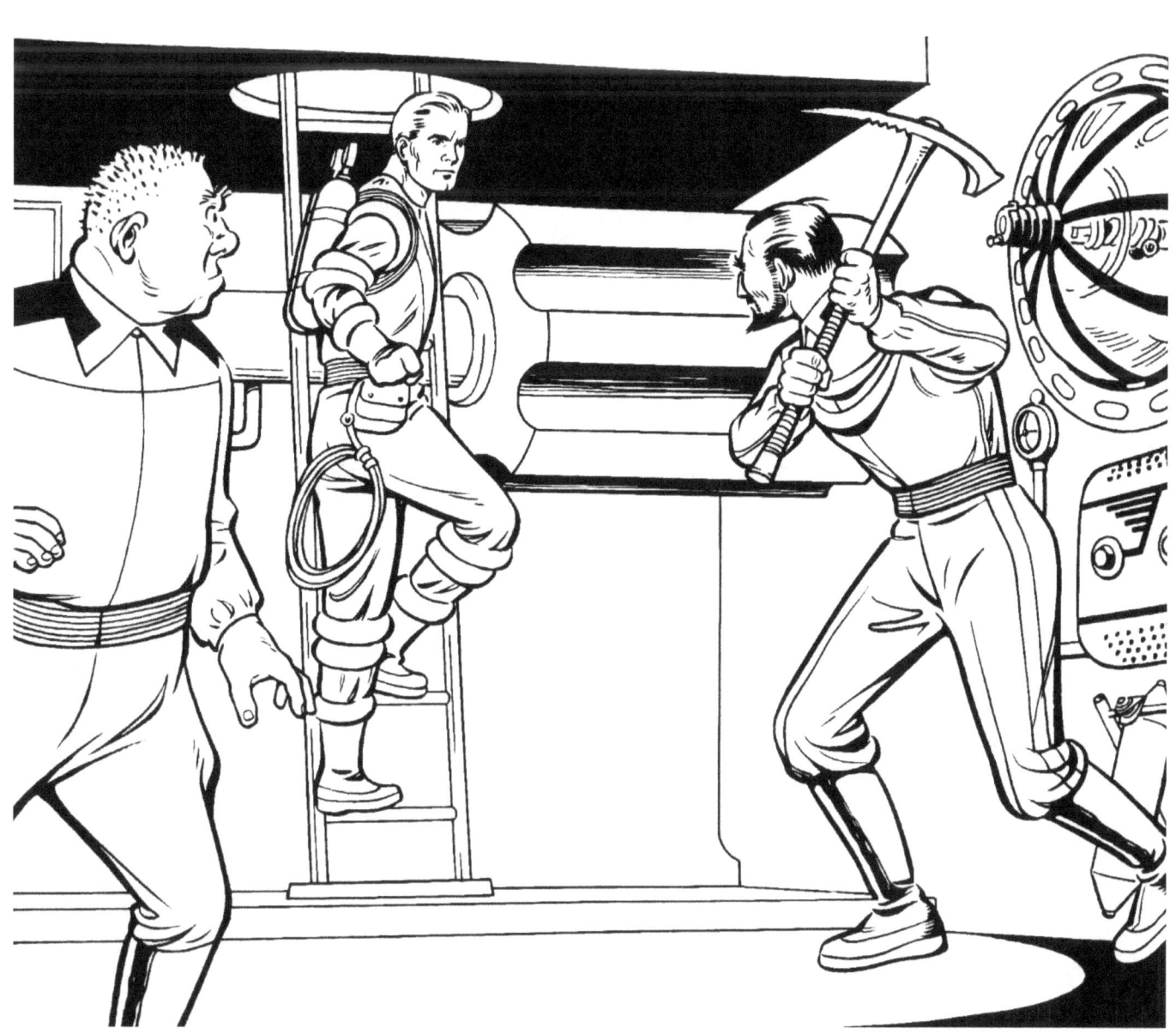

After many other adventures, including a fight on an asteroid, Captain Video completely subdues Octavo and his accomplice, Finch.

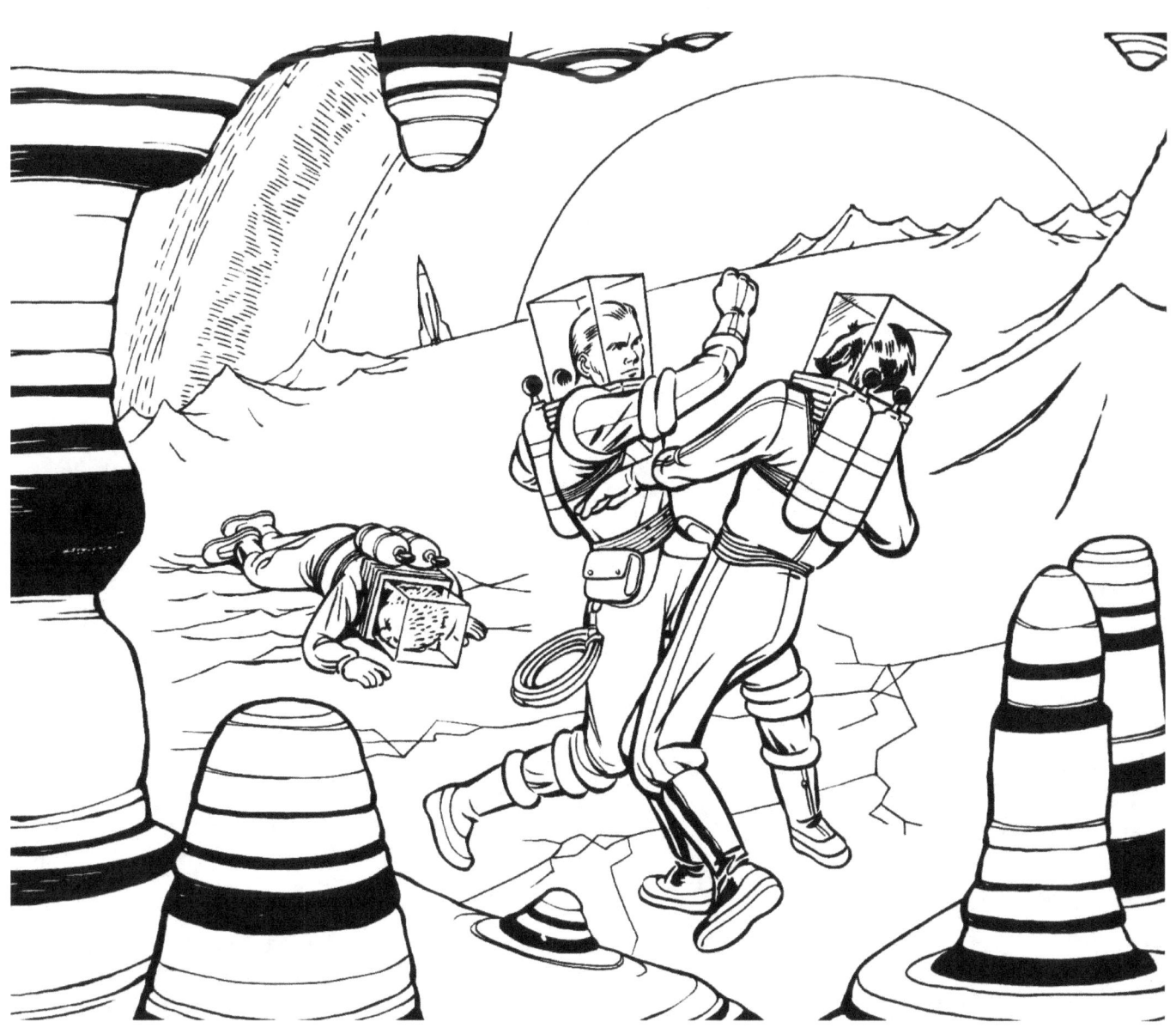

With Octavo and Finch behind bars in the penal colony, Captain Video and the Ranger return to Video's secret mountain hideaway.

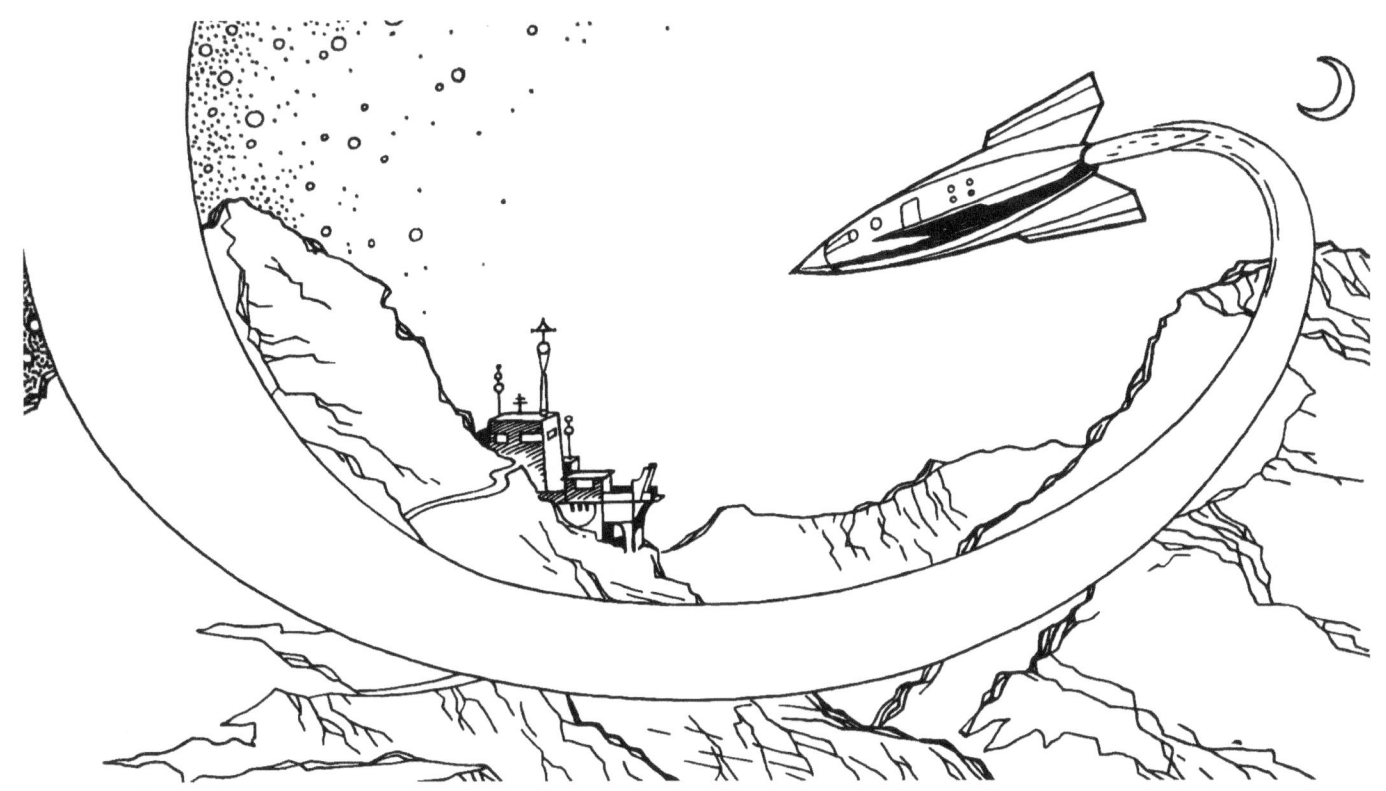

www.ingramcontent.com/pod-product-compliance
Lightning Source LLC
Chambersburg PA
CBHW080944170526
45158CB00008B/2370